# TOWNSCAPES IN WATERCOLOUR

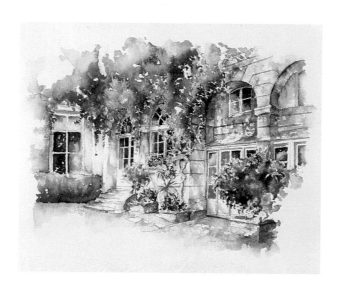

# TOWNSCAPES
# IN
# WATERCOLOUR

Richard S. Taylor

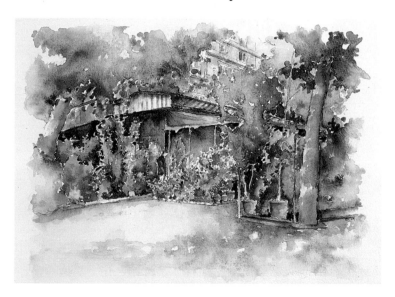

B.T. BATSFORD LTD · LONDON

First published 1992

Typeset by Latimer Trend & Company Ltd, Plymouth
Printed in Hong Kong

Published by B.T. Batsford Ltd
4 Fitzhardinge Street, London W1H 0AH

British Library Cataloguing-in-Publication Data.
A catalogue record for this book is available from the British Library.

ISBN 0 7134 6808 4

*Acknowledgements*
For the 'American Connection' of this book I wish to acknowledge the practical assistance of my friend Dr B. de Cordova (Bobbie), and my sister Gina Taylor.
   I also wish to acknowledge the assistance of my dear wife, Debbie, who did, simply, everything that needed doing.

# CONTENTS

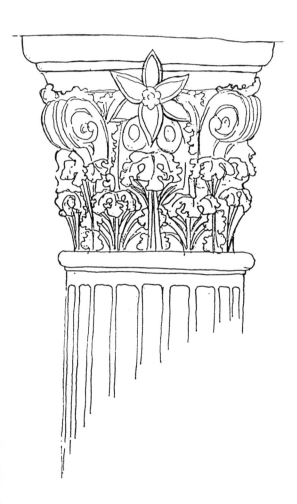

# INTRODUCTION

In my travels throughout Northern Europe and America I have encountered a wealth of architectural styles. I say 'wealth' because I feel considerably enriched by having spent some time amongst them, and I have attempted in this book to express and convey my personal fascination with the urban environment and the pleasure I take in recording it. As a painter, I find watercolour the most proficient medium to use when time is scarce or circumstances do not allow the luxury of a prolonged, leisurely painting session. As a painter with an interest in architecture, I advocate the use of line drawing — not necessarily to place false boundaries on buildings or to create unrealistic casings, but to emphasize the strength and geometrical rigidity of the fabrics from which our towns and cities are constructed. This will be clarified in the course of the book but a few points are worth considering here in the introduction.

I believe it is true to say that the towns and cities that we know today have developed out of necessity. The rural villages that expanded were those that had the advantages of natural resources or good trading positions. Occasionally, good trading positions were found and towns developed as a consequence. Whatever the reasons, the vast majority have developed as a result of trade. It is, perhaps, the excitement of this heritage that makes them appealing places today. The architecture reflects the prosperity, the layout reflects the purpose, and the traditions linger on. The bustle and vibrancy of the urban environment (Fig. 1) injects life into otherwise dull buildings and architectural features.

The attractions of drawing, painting and sketching in the urban environment might not be immediately obvious, especially to the 'rural' artist who has been raised with images of gently rolling landscapes, Adriatic sunsets and scenes of idyllic country peace represented as art. But those of us who stalk the streets and alleyways of towns and cities, sketchbook in hand, know well the excitement of discovery. The small facets of urban decay that are so often passed by can be tremendous subjects for the artist. The painting on the title page is a good example of how a rusty enamelled street sign set against a crumbling stone wall can form a respectable subject for the watercolour artist who enjoys applying washes, and allowing the paper to play a role in the formation of the image. The lichen-covered gateway, the imposing wooden carved door, vibrant lettering on a shop sign, dappled shadows falling on café seats and tables — all of these can be found in the urban environment and are worthy subjects for the artist to consider.

The cities and towns of this world are, in fact, alive with painting material. The ramshackle disorder of a street market or the irregular line of chimney pots

and roof extensions on an urban terrace can create an exciting skyline. Even more exciting can be the ever-increasing combinations of the old and the new, sometimes sitting inharmoniously together. The smooth modern glass development surrounding a corner brick house can provide vital contrasts in shape, tone and texture. Apart from any other considerations, you will be chronicling the age in which you live. Our towns and cities are the first places to reflect our depressions or affluence, and the fortunes of a nation are invariably visible in its urban architecture. The docklands of London, Bristol, Hong Kong and New York are living evidence of this.

Cityscapes, as opposed to landscapes, are a different proposition from the artist's point of view and require a different approach. Unless you can find a position to sit and sketch where you have a panoramic view over rooftops, you will not be as concerned with distance and tonal perspective as you may be with a rural landscape. More often, you will be looking for architectural features (Fig. 2) rather than an expansive scene with vast areas of sky, although this is rarely obliterated in towns and cities. So a

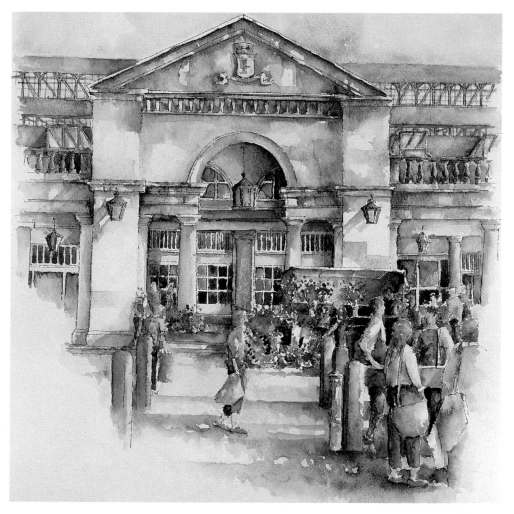

*Figure 1*

7

sketchbook will be a handy accompaniment to any expedition.

The use of a sketchbook and sketchbook studies as being of value in their own right is something considered throughout this book. They can be useful for making a record of urban sites as well as noting your thoughts. Sometimes conditions will allow you to work 'on site' and complete a painting in one session. At other times, you may start but be forced to leave the scene unfinished. Then again, you may decide to take your sketchbook home with you to paint in the safe, warm, windless and dry confines of your own home. No one method of painting has, in my opinion, any ethical superiority. They are all of value in their own right.

———— . ————

*Figure 2*

# SKETCHBOOKS

Sketchbooks are highly personal items. In them you can keep ideas, memories, notes, sketches of friends, incidents, dates and times, details, facets and information. As a teacher of art, I am always keen to see students' sketchbooks but would never insist or pry into the depths of someone's personal notes and recordings without their permission. We can tell much more by looking at an artist's sketches and notes than we often can from their paintings.

Sketchbooks are invaluable for those of us without limitless time, or those of us who want to make some quick visual notes before our subject is blocked out by a bus or has moved on, or indeed before we are moved on by the flow of pedestrian traffic. They can be small, pocket-sized handbooks or A3 size – the only question regarding size is what suits you best. You may well enjoy the feeling of a small pocket book as your constant companion. Alternatively, like me, you may be happier with a hardbacked sketchbook that you can rest on your knees. Whatever your choice, it must be your own decision and will soon come

through personal experience. Sketchbooks are not necessarily expensive to buy, so why not experiment?

I use a sketchbook as a form of 'personal organizer'. I put in information that I feel at the time may come in useful at a later date. I find it helpful to use words as well as pictures, often noting the colours that I have mixed, lettering on signs, the place, time and date, and other specific features that I need to remember. I generally sketch with a pen, a quick and decisive tool (Fig. 3).

I like to centralize my main subject and position round it the features that appear with less detail in the sketch but require special recognition. For me, the important aspects to record in paint are the 'moods' of the day – sharp, strong window reflections or flat, dull colouring; dark, heaving shadows or light, spring-like dappling; inky ultramarine skies or soft light blue above the rooftops. All of these moods need to be captured with decisive use of colour; a few quick splashes will do. If the line sketch is of reasonable quality, then I should have all the information required. Just a quick colour wash will record the more intrinsic aspects of the day. This information, with

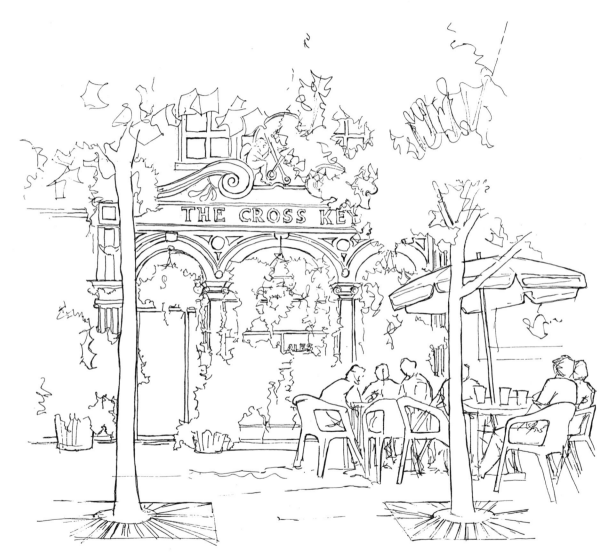

a few memories, can be taken home and developed into a finished watercolour in the privacy of my home studio – the kitchen table.

But, above all this, a sketchbook allows you to keep an autographic record of the places you have visited. The dates and times will all be there with the squashed fly, the indent from someone's umbrella spike as they helped you catch your book on its independent journey along a windswept High Street, the coffee stain from your flask and the telephone number of the person who wanted to commission an original painting. All memories and, in their own way, useful information.

In this book, I have attempted to convey my fascination for the towns and cities that I have visited and return to frequently. I notice the changes and attempt to record them. In the urban environment I find the vitality and life exciting, the architecture charming and the challenge never-ending – I wish the same to you.

————— · —————

*Figure 3*

# ONE
# TOOLS OF THE TRADE

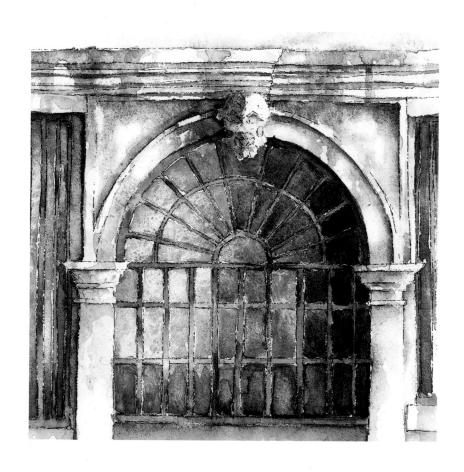

ONE

# TOOLS OF THE TRADE

## PAINTS

Paints and pigments mixed or washed with water have been the subject of artists' experiments for several centuries. The type of watercolour paint we use today became most popular with the nineteenth-century artists in England who subsequently became known as the 'English School'. They included such prominent painters as John Sell Cotman and J.M.W. Turner, who experimented freely with watercolour both in Britain and Venice. One nineteenth-century painter rarely associated with watercolour was Paul Cézanne. Cézanne, one of the founding fathers of the Impressionist group of painters, discovered that watercolours allowed him the spontaneity to record form and colour – the fundamental elements of his own work – which were essential to the Impressionist creed of capturing the fleeting effects of light. Ian Simpson in his book *Painters' Progress*

describes the appeal of watercolour: 'Simple washes can be used to build up a very complex surface full of shifting shadows. The feeling of depth and perspective is the result of layers of paint drifting quietly away to a subtle glimmer of colour for the background.'

Today watercolour paints are basically the same as they were when Turner and Constable toured the countryside sketching and painting, only now they are commercially available. The essence of watercolour paint is colour pigment mixed with a binding agent. When water is added a translucent wash is created, and when this is applied to paper the water evaporates, leaving a coloured residue. The binding agent prevents this residual paint flaking and blowing away.

Watercolour paints can be bought in two main forms, in pans or tubes. Tubes allow you to achieve more intense colours but are not as convenient to transport as the pan paints, which sit inside a

box. The pans themselves have several variables. You can buy either artists' or student quality, in full or half-pans. The artists' quality pans are the better-quality paints and will not dry to such a 'gritty' texture as some of the cheaper paints. Student quality are the next stage down and are perfectly acceptable for quick sketching and recording. Half-pans are, reasonably enough, half the size of the full pans.

The boxes and tins that these paints come in are the next consideration, not to be confused with children's toy paint tins. They are available in a wide range of sizes and prices, from simple plastic boxes holding six pans through to clever folding tins with collapsible sable brushes, rings and tiny waterpots. The vast majority have replaceable pans. Consider what you need before buying.

The most suitable paints for sketching and recording on site are any of the variety of self-contained tins. These are

generally pocket-sized and sit in one hand. Don't be afraid to 'test hold' them in the shop to make sure they feel right for you. My choice of paints is as follows: Yellow Ochre, Burnt Umber (brown), Burnt Sienna (reddish brown) — the basic, natural, earthy colours — and Prussian Blue, Sap Green, Cadmium Yellow and any red (usually Vermilion).

## PENS

For sketching and line work, I use an Indian ink pen (cartridge variety, with just the one-size nib) for the spontaneity and clarity of line that such a pen can produce (Fig. 4). Many types of pens exist, but it is as well to be aware of fibre tip pens. These are often sold in art shops as being suitable for drawing, and so they are, but they are not always water-resistant and a line drawn with such a pen will often bleed if washed over, leaving a purple stain in its wake. If controlled, this can be an interesting technique, using simply a fibre pen and a wet paintbrush, but it is not suitable for use with water *colour* as the bleed will affect the colours and tones, as well as leaving a 'fuzzy' line.

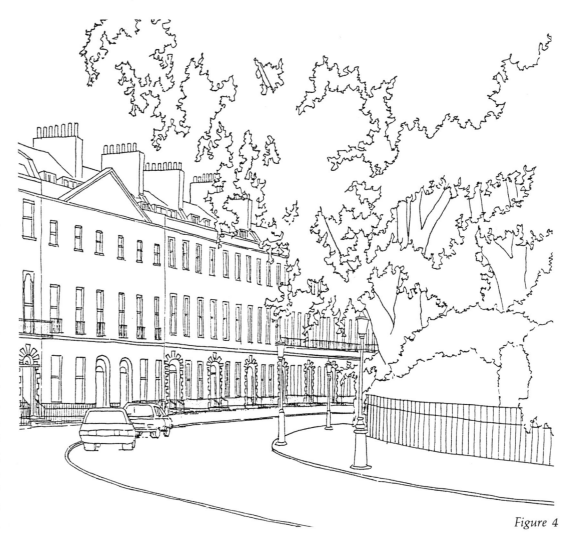

*Figure 4*

Most ink pens, or 'technical' pens as they are often called, are available with interchangeable nibs. I use a 0.25 nib, which is a middle size and suits most types of drawing or sketching. It is not so fine that it scratches the surface of the paper, but it is thin enough to record intricate details with confidence.

## BRUSHES

Brushes come in many sizes and types, but can be divided into two main categories — sable or synthetic. Pure sable brushes are expensive but worth buying. They feel good to work with, they hold water well and maintain their points under heavy-handed treatment. Synthetic brushes are, in general, as good in their water-holding properties and pointing qualities, and will probably last longer. As with many aspects of art, you need to try the various types in order to assess which suits your personal requirements best, and in particular which you enjoy the feel of most. You may well like the feel of a long-handled brush, or a shorter one may sit better in your hand. Try them and see.

It is probably as well to have one large wash brush. A long-handled brush with a 2.5 cm (1 in) head will cover most wash requirements. For applying colour, I tend to use only three brushes: size 2 for tiny detail work, size 5 for general work and size 10 for applying colour washes to large areas. My personal choice is for long-handled synthetic brushes — but my tastes are simple. Throughout the rest of this book, I shall refer to these three brushes as either small, medium or large.

## PAPER

Watercolour paper is traditionally sold in three main grades, plus expensive hand-made papers which often appear on a separate shelf altogether. 'Not' is a rough-textured paper, ideal for creating textures in old weathered stone (Fig. 5) and particularly suited to the washing and blotting technique described in the following chapters. 'Cold press' is a medium-range paper, generally suitable for all levels and types of watercolour work. 'Hot press' is a smooth paper, good for line drawing and watercolour tinting. The basic differences concern the texture and control of the flow of paint. The 'Not' paper is suitable for painting with lots of water and colour as it absorbs well. It is not conducive to pen work as the rough texture will break the free flow of a pen line, blocking the nib with an accumulation of fibres. It is an expressive paper which will stand much punishment, but you must be prepared to allow the paper to control the painting at times. The 'hot press' is suitable for drawing on as its smoothness allows an uninterrupted free flow of ink from a pen and will facilitate accurate drawing and sketching, whilst still taking a watercolour wash. It is perfect for the architecturally inclined. 'Cold press', as stated, is a medium-range, general-purpose paper ideal for beginners.

These papers often appear in shops with different names or categorizations, for example, smooth, rag and rough. Another variable is weight. Paper is sold in varying weights: 90 lb (190 gsm), 120 lb (255 gsm), 200 lb (425 gsm), etc. The heavier the weight, the stronger and thicker the paper will be.

Loose, or sheet, paper is all very well for working at home where you have no need to transport sheets, but it is

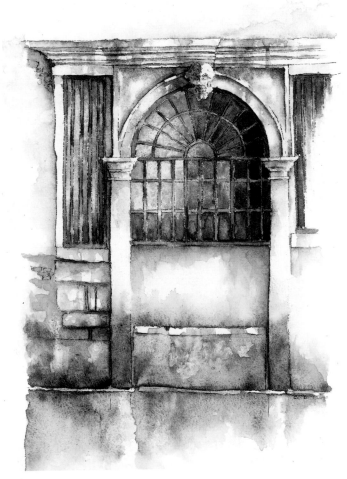

*Figure 5*

not really suitable for sketching on site unless you cut it up and create a type of folder. Even then, the sheets will be liable to loss or damage in windy conditions. My advice is always to buy a ringbound hard-backed watercolour pad of paper in the 120 lb (255 gsm) region. This will allow you to rest your pad on your knees, eliminating the need for transporting a heavy, cumbersome drawing board on your painting expeditions. Your work can be transported from site to site without becoming creased, folded or torn as it is packed and unpacked from your bag. I find that an A3 pad is most easily transported and is the best size for either sketching or painting. Experienced painters will have established their own ideas about equipment, but for the beginner I advise starting with an A3 watercolour pad. Very small sketchpads are handy for transporting, especially the pocket pads, but they only allow you a very small surface to sketch on and are best left until you have some experience or have practised a little. A1 pads are much too large and cumbersome for working with on site.

One other consideration regarding paper. Very heavy paper will respond

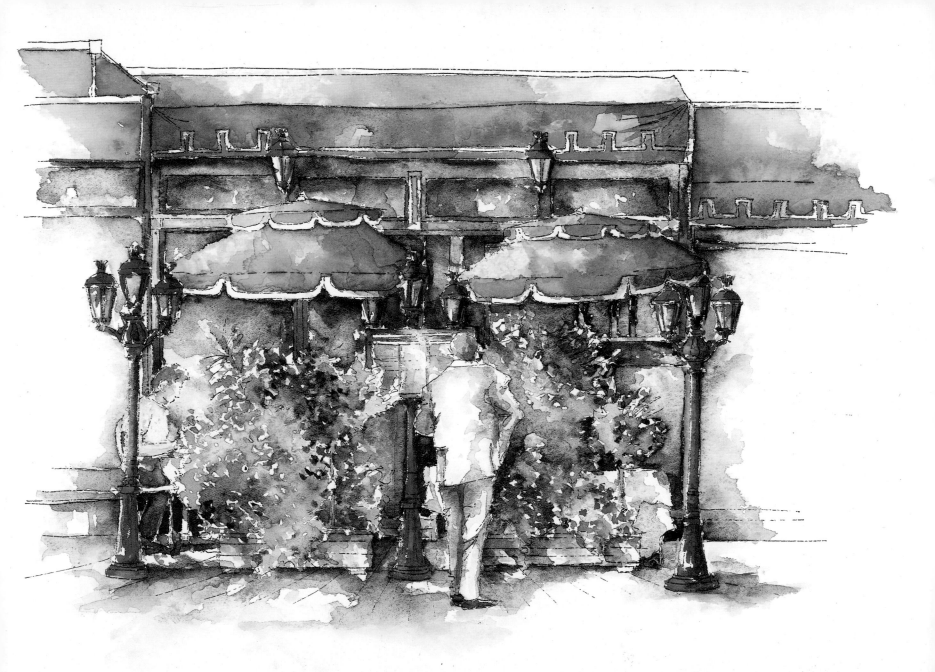

differently to the thinner papers when treated to a series of successive washes. The thinner paper will contract as it dries, leaving a 'wavy', buckled sheet. The thicker paper will also contract but not to such an extensive degree and it will certainly be less noticeable. All of this can, however, be avoided by 'stretching' the paper before you undertake any painting. Personally, I never bother to stretch the paper I take out of doors for sketching as it rarely receives much water — only a few quick, light washes are generally applied at the sketching stage — apart from which the paper would have to be removed from the all-important spiralbound pad. For more serious painting sessions, however, or for when you return home and wish to transfer your sketches onto a larger sheet of paper, stretching is advisable.

The technique for stretching is very simple. First dampen the paper thoroughly on both sides, using a clean sponge. Then smooth the paper down on a clean drawing board and stick down the edges, using brown tape. As soon as this has dried, cut the paper away, using a sharp knife. The paper will then remain flat however many washes you apply.

# OTHER EQUIPMENT

Having considered the main tools of the trade, it is now time to spend a few minutes examining the peripherals, which are equally necessary for working on site. A plastic watertight container is essential. This does not need to be large as you do not really need a lot of water, but it needs a really close-fitting top to prevent leakage if you are likely to be moving frequently. Then there is the consideration of how to transport your equipment as you travel the city streets in search of subjects. Many art shops now stock a wide range of satchel-type bags with A3 compartments for sketchpads, small pockets for pens, brushes, etc. and some even come complete with inbuilt water pots. These are very smart and make excellent presents, but the khaki canvas bags with several pockets that you will find in your local Army surplus store are just as efficient and considerably cheaper. Whatever your choice, make sure there are no holes in the stitching for pens and brushes to fall through.

One final consideration on the subject of equipment. Throughout this book I refer to techniques for painting on site out of doors, and for working at home indoors. One particular item of equipment that I have found invaluable when working indoors is a 'daylight' lightbulb. Artificial lights, especially with shades, and fluorescent light strips, however bright, will affect your colour vision. Paintings carried out in artificial light will look considerably different when viewed in natural light. 'Daylight' bulbs help to neutralize this effect by providing a good strong working light with enough natural qualities to allow you to mix colours with confidence.

So these are the main tools of the trade that I recommend and have, myself, found invaluable over a period of many years' drawing, sketching and painting in towns and cities in Europe and throughout America. As I have emphasized, your own personal preferences for equipment will develop out of your own trials, experiments, requirements, and ultimately experience. You will soon build up your own personal choice of colour, size of brush, and weight and texture of paper as long as you are always prepared to experiment.

———— · ————

# TWO
# MAKING A START

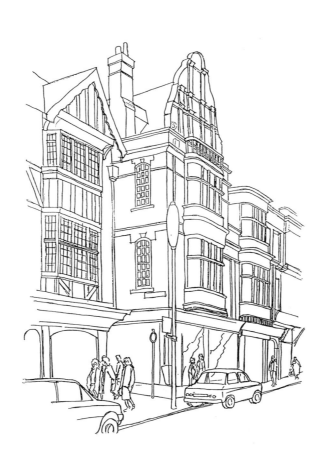

# MAKING A START

First of all, we need to consider perspective. Perspective is all about illusion – optical illusion. By employing perspective within a drawing, you are attempting to trick the viewer into believing that you have created a three-dimensional image on a two-dimensional surface. Of course, you have not. You will only have created the illusion of depth, relative shapes and sizes and space by clever use of well-positioned lines. Some people like to develop perspectives within the safe confines of complex grids based on a mathematical formula developed in the Middle Ages. Others prefer to use guesswork and visual intuition. In the following example, I will attempt to bridge the gap between these two extremes, and to introduce a simplified method of rendering shapes using the minimum of construction and guesswork.

Fig. 7 illustrates one-point perspective, which is based upon the principle that all parallel lines *appear* (of course, they do not) to meet at the same point on the horizon – this point is known as the vanishing point. If you were to stand in the centre of a straight desert highway, the road would appear to become narrower as your eye followed it towards the horizon. The sides of the highway would appear to converge on the one final point (Fig. 7a). If a series of telegraph posts were introduced into the picture (Fig. 7b), the bases of the posts would appear to follow the line of the road (up towards the vanishing point) and the tops would appear to converge down towards the vanishing point. As all lines appear to converge to the one point of construction, this type of perspective is simple. It is, however, unusual for artists to employ one-point perspective in a composition. It is much more usual to adopt the two-point perspective method of drawing and sketching buildings from ground level. This allows you to record buildings, posts, walls, etc. from an 'angle'. If a cube or box is viewed from its edge, it will appear in two-point perspective (Fig. 8a). If the horizon represents your eye level, the lines of the top and the bottom on each of the two visible sides will appear to converge to their own respective vanishing points. Fig. 8b shows how the principle works when several boxes are constructed in this way, with all of the sides appearing to converge to exactly the same two vanishing points on the horizon.

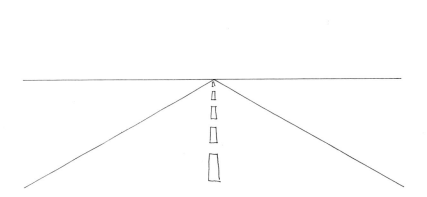

*Figure 7a*

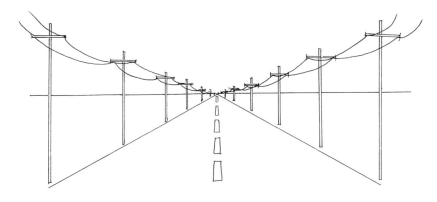

*Figure 7b*

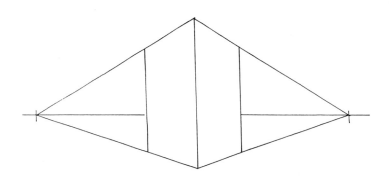

*Figure 8a*

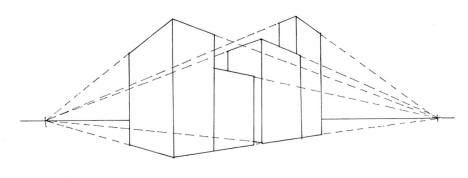

*Figure 8b*

## FIGURE 9

The next step involves a method of 'box construction'. This involves not seeing, but perceiving, buildings as box units — which, generally, they are. This next set of diagrams illustrates how a group of High Street buildings can be reduced to their most basic geometric form — the cube (Fig. 9a). This allows the simplest of perspective constructions. In towns or cities, you rarely see a horizon so it would be of little value to examine perspective construction methods here. Instead, try to judge the angle of convergence between the top and bottom lines of the building(s) and sketch these. Then, simply make sure that all other lines converge (on either side) in relation to the others and that they would, ultimately, appear to reach the same point as the top and bottom lines (if such a point could be seen).

A few practical hints may be of value here. As you will generally be seated when sketching or drawing, your visual horizon will be lowered. The angle of convergence of the upper edge of your building (generally the roof) will increase as a consequence. All of the angles will look different when you stand up to stretch your legs, but don't be put off by this. You will also always be looking up from ground level (if that sounds a little obvious, be patient!). As a result, you will rarely see the ridges on roofs, and almost certainly never the tops or insides of chimney pots. You will usually be looking up towards the underside of window ledges and eaves (Fig. 9b), and you will need to include these in your preliminary sketch. (Incidentally, this does not need to be the one you ultimately paint. Why not try a few quick sketches before you commit yourself?) In addition, some very interesting and rewarding views are to be found from the windows of town houses and city apartments — looking down on the world can be as interesting as watching it pass you by at street level.

The other key point to remember is always to make sure that your parallel vertical lines remain vertical. It is a common fault when first experimenting with perspective 'on site' to allow vertical lines to lean a little to the right as they move to the righthand side of the page, and the same to the left. This can be avoided by rolling a pen or pencil across the page to check that all the lines are vertical.

*Figure 9a*

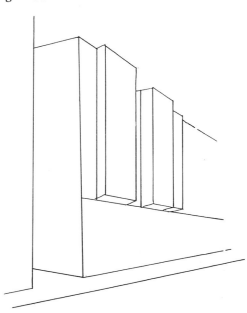

*Figure 9b*

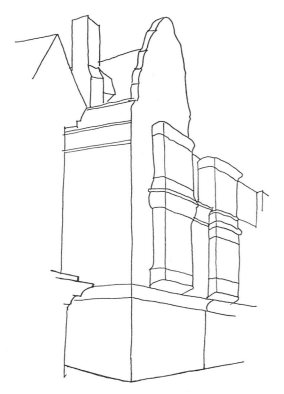

*Figure 9c*

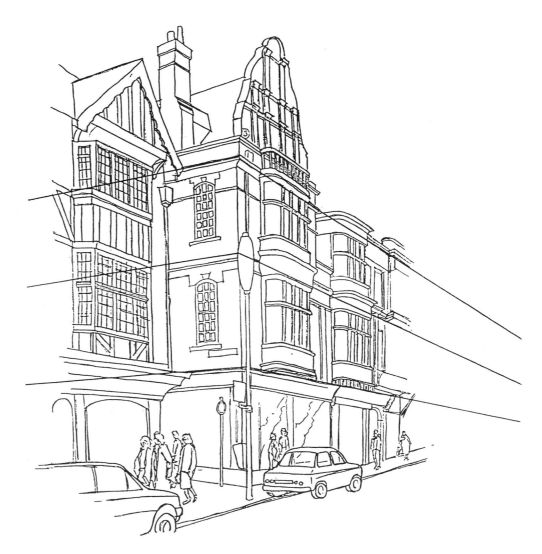

*Figure 9d*

24

Fig. 9c illustrates how the box construction is developed, through the simple addition of a little detail and the inclusion of the undersides of balconies, etc., to the very detailed drawing of a busy provincial town High Street (Fig. 9d). I have included the perspective construction lines that are appropriate to the main corner building to show that a little guesswork and visual intuition can work as well as mathematical construction — it will always give a little more 'life' to your drawing, even if it is not 100 per cent accurate.

——————— · ———————

## FIGURE 10

To conclude this section on 'making a start', I include an example of the method of instruction that I employ throughout the book. As an urban artist, I always seek subjects that offer texture, solid blocks of light and shade, and the vital elements of geometry or symmetry. I chose this Parisian gateway (finished painting on page 30) as it was uncomplicated by acute angles and perspective, and allowed me to give my full attention to the textures and interplay of light and shade seen on this type of stone structure. A perfect example of how to enjoy watercolour painting!

I started with a pen sketch (using a 0.25 nib) on 120 lb (255 gsm) watercolour paper, still attached to its ringbound pad. I picked out the key features and architectural details that would not lend themselves to paint alone (Fig. 10a). The highly detailed motif above the gate clearly benefits from the strength of line in its details.

The next stage was to prepare my painting equipment. This meant having everything that I was going to use ready to hand — water container filled with water, sheets of kitchen roll already torn off, and my three synthetic brushes all on my righthand side. My palette (pan paints and mixing tray in one) was, of course, in my left hand. As mentioned previously, I prefer to use a very limited range of paints, since this encourages mixing rather than reliance on predetermined tints and tones.

The first painting step (Fig. 10b) was to dampen the paper slightly to allow an even and free flow of paint on the first coat. This encourages those fortunate accidents when the paint bleeds and dries in areas that we had not anticipated, creating textures, enhancing lines and forming shapes that suggest images we had not even considered, especially when painting stone and brick. Before this water wash, applied with a large brush, had started to dry, I quickly applied the base colour of Yellow Ochre to all sections, including the foliage. A mixture of Sap Green and Burnt Umber was then quickly washed across the top and under the gate, and allowed to bleed freely with the ochre, completing the undercoat.

The next stage (Fig. 10c) was the 'push-pull' technique whereby the background areas were darkened, in turn

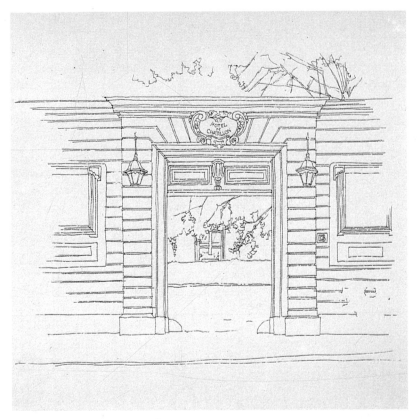

*Figure 10a*

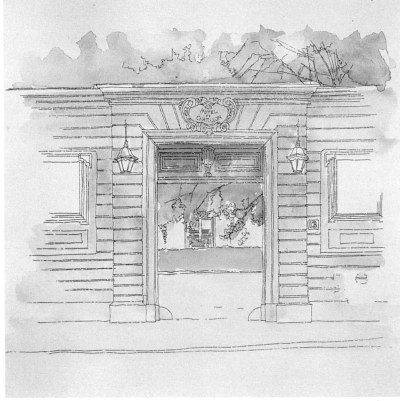

*Figure 10b*

pushing the 'lightness' of the foreground forward. I intensified the mixture of Sap Green and Burnt Umber by increasing the quantities of paint (with no more water), and applied this to the still-damp undercoat. The main bulk of the shading in the trees was to the righthand side of the composition, so that was the place to make the first application of paint. This was not so much a brushstroke as a brush 'drip', allowing the paint to run from the brush onto the damp paper and bleed outwards from that spot. Since there was not much distance between the background and the foreground, it seemed appropriate to leave the background without a lot of detail – just the few blocks of colour that the paint had created. Any more detail could have confused the composition.

The main interest of this Parisian gateway was the texture created by over a century of city grime, damp and mould. This (Fig. 10d) is my favourite part. Using a medium brush, I made a mixture of Burnt Umber and Prussian Blue and applied it to the appropriate patches, once again allowing it to bleed freely. These bleeds were then blotted with kitchen roll in selected patches to create another type of texture. This technique instantly removes the wetness from the sheet, leaving the pigment to stain the paper, so that you can control both the speed of drying and the direction of the paint you have applied. All of the 'patchy' areas of mould were created by selective wetting, bleeding and blotting across the composition.

The last stage of this painting (Fig. 10e) was to add the shadows and shading. Paris has always been well known for its sharp light. The late spring day on which this composition was painted was flooded with this wonderfully atmospheric light source. Using a small brush, which allowed me to tackle the finest shaded areas, I intensified the Prussian Blue and Burnt Umber mixture as before and applied this in lines under the ledges and cornices, and on the appropriate sides of the carvings and mouldings. Before this had had time to dry completely, I ran along the thin lines with a wet paintbrush, 'pulling' the paint out of the shadows. As only water was on the brush, the paint diluted as it was pulled outwards, creating a graduated shading effect while leaving an intensity of paint in the immediate shadows.

The ground colour was the last section to be painted. The ground area was dampened with a wash of clean water, using a medium brush. To capture the mottled shadows cast by the chestnut trees, a combination of the initial ground colour (Yellow Ochre, Burnt Umber and Prussian Blue) was mixed. This was then quickly washed onto the damp paper and allowed to bleed for a few seconds only. The mottling was created by blotting out small dabs, recreating the shafts of Parisian light.

The very final touches, such as the blue enamelled house number, the lamps and the characteristic red geraniums in the windowbox, were all added with a small brush.

This painting required a level of geometric awareness in its sketching, but little perspective. The paper was allowed its fullest level of creativity, making a highly textured composition.

———— · ————

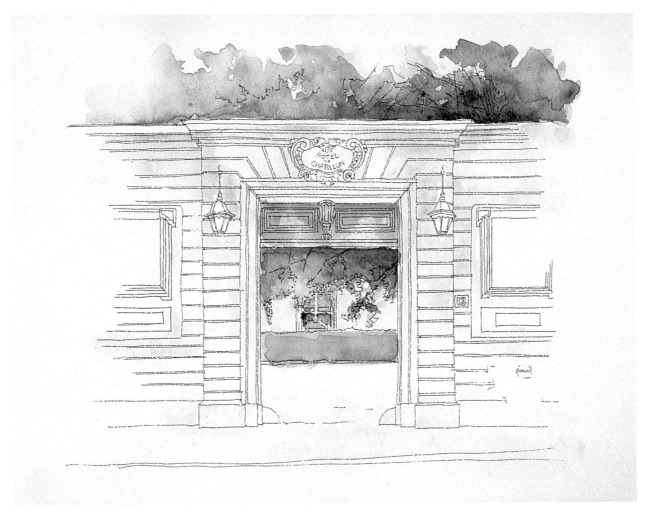

*Figure 10c*

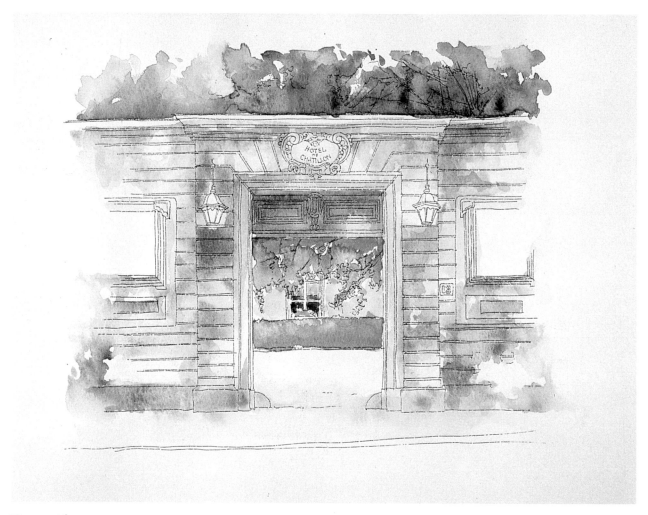

*Figure 10d*

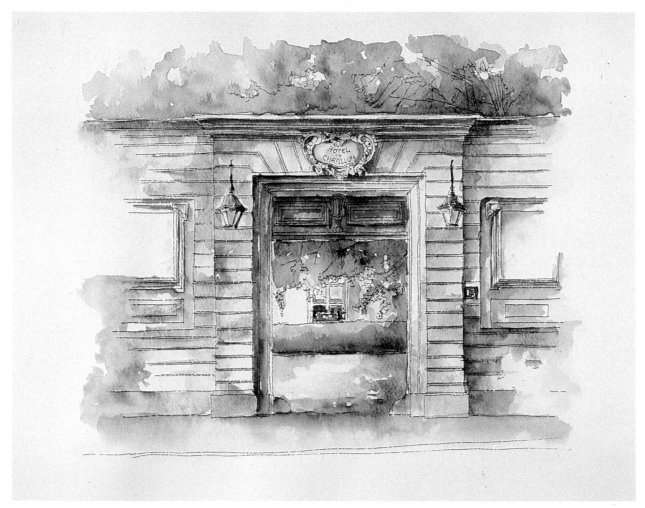

*Figure 10e*

# THREE
# URBAN ARCHITECTURE

# URBAN ARCHITECTURE

The urban environment can be the most frustrating and the most rewarding of environments in which to work. Vast expanses of terraces and massive concrete constructions all have their merits for the artist. It is just a question of training yourself to look for the small details or decorations that make a flat wall interesting, or the ornamental carvings that enhance a dull doorway. All of these are worthy of the artist's attention and a pleasure to record in a sketchbook.

Much of the decoration that we find on urban buildings today has its origins in early Greek architecture. The columns developed to support roofs are frequently copied, often in relief, to add interest to an otherwise plain doorway. The capitals with which the Greeks decorated the top of the columns are the most commonly copied of their magnificent decorative designs. To understand how best to record these decorations it is well worth spending a little time considering their origins — understanding a subject is always a valuable asset to the artist.

The Greeks were great lovers and respecters of Nature, and frequently turned to Nature for their visual inspiration. The designs they developed ranged from the simple copying of a leaf, turned over at the top, to an extremely complicated volute based upon a mathematical modular formula taken from the proportions of a whelk shell. Leaves, rams' horns and shells were the origins of the majority of their decorations. Although progressive 'orders' developed much more elaborate designs, whose origins are difficult to see, you can nearly always identify a leaf, shell or horn shape somewhere.

Columns are interesting features for the artist to consider because they were designed specifically for their visual effect. The columns appear to be thinner at the top than they are at the bottom, as is indeed the case. This gives a carefully planned and proportioned exaggeration to the perspective, making the columns seem elegant and higher than they really are — a clever perspective trick and worth remembering if you are sketching them. They were built to deceive the eye, so do not make your angle of convergence too steep.

There is today (and very welcome, in my opinion) a revival in the use of classical decoration, even on functional buildings. Of course, classical decoration is not the only form to be found. Ornamental railings, balconies, tiles, statuettes, gargoyles, mouldings, carvings and even clocks are seen gracing many urban buildings. They are often the work of craftsmen and deserve a page or two of anyone's sketchbook.

———— · ————

## FIGURE 11

The following series of step-by-step illustrations shows the method I used for recording the type of Greek capital to be found gracing certain elaborate city buildings. Having completed an initial pen sketch of the lines of the leaf and horn shapes (Fig. 11a), I introduced a wash of watery Yellow Ochre to act as an undercoat, covering all of the white paper (Fig. 11b). This took only a matter of minutes to dry. The study was next treated to a darker wash of Yellow Ochre, Burnt Umber and a touch of Prussian Blue, washed on with a wet brush (Fig. 11c). This was allowed to bleed a little, then blotted on the right-hand side (the side on which the light was falling, leaving the other side in shadow) with a sheet of kitchen roll. The last stage (Fig. 11d) was to load a thin, dry brush with a mixture of Burnt Umber and Prussian Blue, and to add the delicate shadows. This involved looking into the righthand side of the raised details and painting a thin dark line along their edges. The brush was quickly rinsed, and then, using water only, washed over the paint before it had time to dry on the

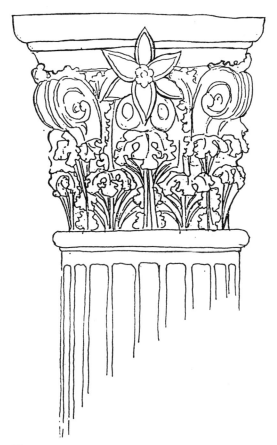

*Figure 11a*

paper, pulling it into the shaded side. This technique helps to produce a graduated shading effect, emphasizing curved surfaces.

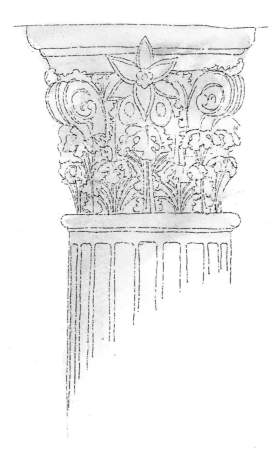

*Figure 11b*

## FIGURE 12

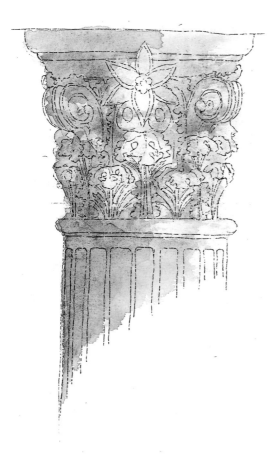

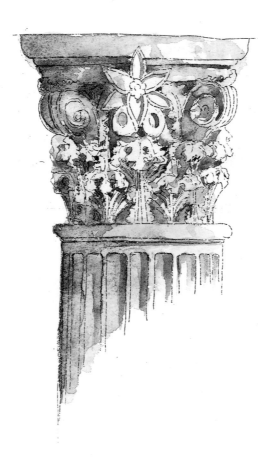

This next sequence charts the progress of an example of solid Edwardian urban architecture from sketchbook stage through to a larger 'finished' watercolour painting. The sketchbook page (Fig. 12a) relied very heavily on strong line drawings. The day was fine and the lighting good – perfect for sketchbook studies. I decided to make the doorway and its highly decorative surround the central feature. The windows themselves were not of any great decorative interest and so were given sparse treatment, simply acknowledging their existence. Had it not been for the decorative wrought-iron lamps I would probably have allowed the sketch to 'run out' halfway down the steps, but they were too good a feature to leave out, necessitating the inclusion of the bases in the sketch. I then picked out some of the key decorative features of the door surround to record on a larger scale (Figs. 12b–e), allowing me to see the detail properly on my return home. The ram's head with horns and flowing beard was a key decoration at the top of both balcony supports, and the leaf designs featured throughout.

*Figure 11c*

*Figure 11d*

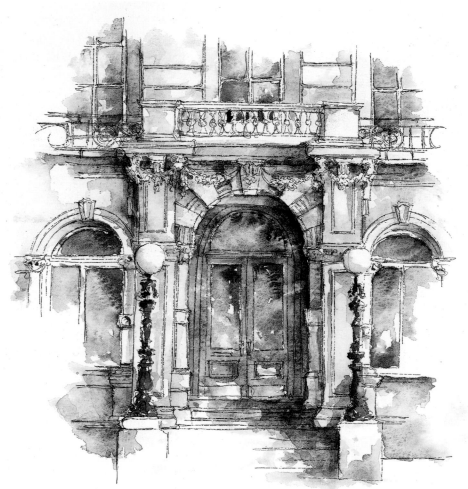

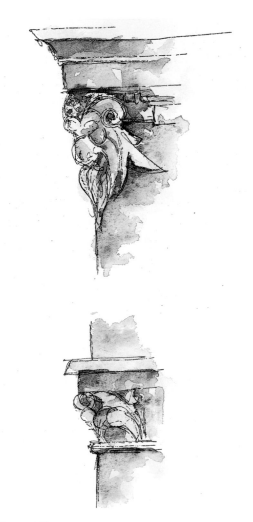

*Figure 12a*

*Figure 12b*

*Figure 12c*

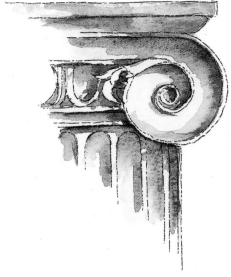

*Figure 12e*

*Figure 12d*

The colour wash was very simple. A mixture of Yellow Ochre and Burnt Sienna was mixed in the plastic lid of my paintbox and applied with a very wet medium brush. I did not wet the paper first so the paint dried quickly. This then allowed me to add a touch of blue to the mixture in my lid and, using the same brush, to apply a few strategic strokes to the shaded areas – under the balconies, ledges, and decorations – recording the direction of the light and subsequent extent of the shadows. The paper was then selectively blotted with a piece of kitchen roll to create highlights, and to recreate the patchy look that warm stone can take on in early summer light. Finally, the windows were treated to a quick wash of Prussian Blue mixed with a touch of Burnt Umber which was, again, selectively blotted to produce the reflections and to record the mood of the day. The sketch was then complete. Having recorded the shape of the central feature of interest in line, noted the details of the decoration and applied a quick colour wash, I had all I needed – an interesting sketch in its own right, as well as the makings of a finished painting.

Making the transformation from sketch to finished painting need not be an intimidating experience. After all, you have your original which will remain constant throughout. One method often employed by artists of all persuasions is that of 'squaring-up' (Fig. 12f). This involves drawing a grid (preferably in pencil, as your original then remains intact) of squares across the picture to be transferred or enlarged. Then draw a proportional grid (enlarged if required)

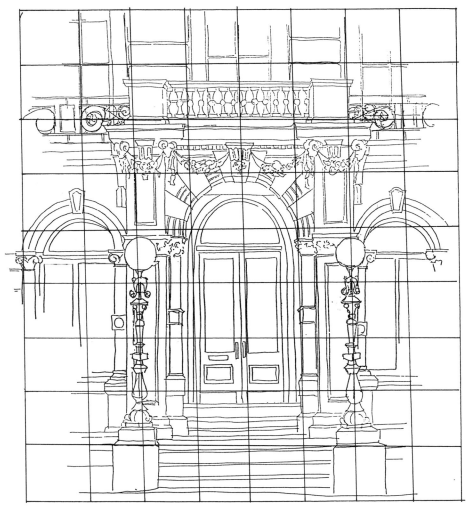

*Figure 12f*

on the paper to be used: for example, 1 cm squares enlarged to 1 in squares, or simply a 1:2 or 1:4 ratio – whatever is appropriate for the size required. This method then allows all of the detail in the squares to be uniformly transferred.

The first stage of this process is to transfer the line drawing onto a sheet of previously stretched watercolour paper. This particular drawing was done with an Indian ink pen on 120 lb (255 gsm) paper.

It is always important to check for symmetry on doorways and windows before you start to paint. Make sure that, visually, the curves are symmetrical with no points at the top. Also check that an imaginary line running through the centre would touch all the centres – double doors, window frames, etc. The squaring-up process should help you considerably with this as you will have both a vertical and horizontal grid to check against.

When you are satisfied that the drawing is ready, it is time to start painting. Whether you are working out of doors, at home, or in a teaching or studio situation, it is always a good idea to have your paints laid out ready beside you – never in front of you, as you will

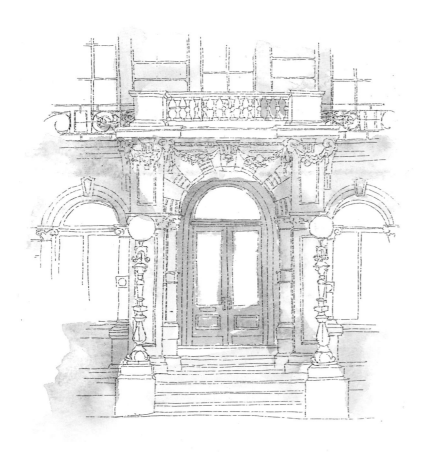

*Figure 12g*

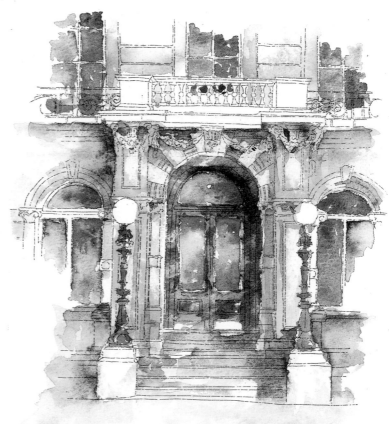

*Figure 12h*

drip and splash across your picture as you are working. Having organized a space with paints, water pot and kitchen roll at hand, the real work can begin.

The very first act with this embryonic painting was to dampen the paper with a medium brush (Fig. 12g). This simply involved covering all of the stonework with a clean water wash. As this was drying, but before it had dried completely, an undercoat of Yellow Ochre and Burnt Sienna was mixed and applied to the damp area with a medium brush. The basic stone colour that I use is a mixture of Yellow Ochre and Burnt Sienna for warmer stones, and Yellow Ochre and Burnt Umber for deeper, older fabrications.

When wet paint is applied to damp paper it will 'bleed', often running into places where you don't want it. When this happens, simply blot it out with a sheet of kitchen roll. I would also recommend a good, scrumpled-up piece of kitchen roll to add texture to your brickwork. Blotting paper leaves the paper looking too smooth.

A little Burnt Umber was added to the paint mixture in the palette to darken it and was applied to the wooden door.

The basic undercoat was then complete and left for a few minutes to dry.

The next stage (Fig. 12h) required the addition of blue to the same mixture to establish the major shadows, and also to introduce the windows. For the windows I used Prussian Blue with the addition of a little Burnt Umber to neutralize the tone. This was carefully applied to dry paper, using a wet brush, allowed to flow a little (as opposed to uncontrolled bleeding) and blotted at the outside edges of the composition. I often use this compositional technique — it eliminates hard, straight edges, which can be a distraction, and emphasizes the centre of the composition by drawing the viewer's eye towards it.

Keeping the paint mixture intact on my palette, I then added a little more Burnt Umber for the shadows. The major shaded areas were painted on using a wet medium brush and, again, allowed a little freedom to find their own way across the paper. A little blotting was required on the steps and door to prevent the whole of these areas being cast in shadow — a few highlights are important where strong lighting is involved. This was then left to dry.

The final stage (Fig. 12i) involved almost 'drawing with paint'. The highlights and shadows of the relief decorative carvings required special attention. Having painted the major shadows, it was time to work on the minor ones. A small brush was chosen for this part of the painting, only this time I made sure that it was dry before loading it with paint. This maximizes your level of control as there is no water to run out onto the paper with the paint. The same mixture of paint was used — Prussian Blue and Burnt Umber, without any addition. There was no real need to increase the density of the paint as each layer added to a watercolour wash darkens it automatically — the more applications of paint, the darker the tone will become. With shadows, always look underneath. Underneath balconies, arches, window ledges, carvings — anywhere where there are protrusions, there will be shadows. It is by tracing the delicate latticework of shadows across decorative carvings that the highlights stand out even more. If you run a shadow along the edge of a carving, it will emphasize the relief, making your pictures come alive with shadows and highlights.

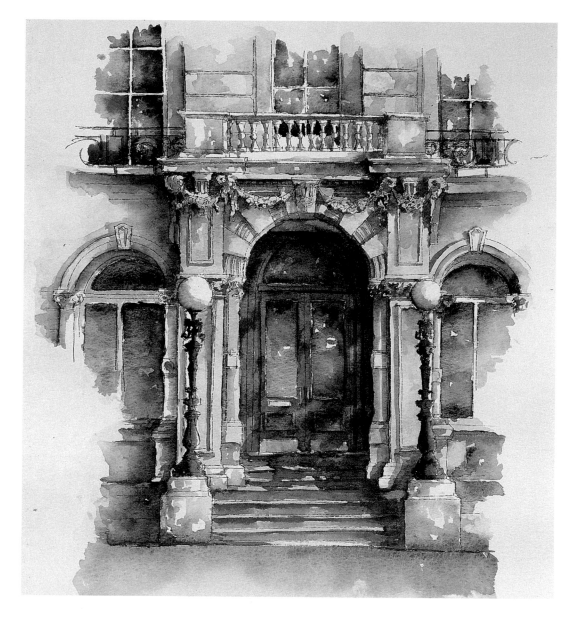

This symbol of Edwardian grace and dignity served well as a painting subject. Every indentation was shaded and every relief emphasized until the picture was complete. The intricate decorations were intriguing to record and the warm stone cast a pleasant glow upon a proud architectural monument, the civic town hall, found in every country throughout the world and always a suitable subject for the watercolour artist.

*Figure 12i*

# TOWN HOUSES: WINDOWS

A visually, and historically, interesting feature of the urban environment is the Georgian town house. These magnificent buildings enhance towns and cities throughout Britain, especially Ireland, and formed the basis for the design of 'colonial' homes in America, Africa, India and Australia (Fig. 13). Once again, an appreciation of their origin helps us to understand how best to treat our recording of them.

The artist and architect Inigo Jones was struck with the work of the Renaissance designer Palladio during a visit to Italy in the late seventeenth century. On his return to England, he set about producing designs for domestic buildings based upon the grand Palladian mansions of the Italian princes. These were based on a mathematical block formula to create the optimum visual appeal. They were generally three storeys high from ground level, with a storey below ground for the servants. The block construction featured a magnificent, often imposing, doorway in the centre of the house. A stairway led up through the building, with rooms on either side. Each level of windows

*Figure 13*

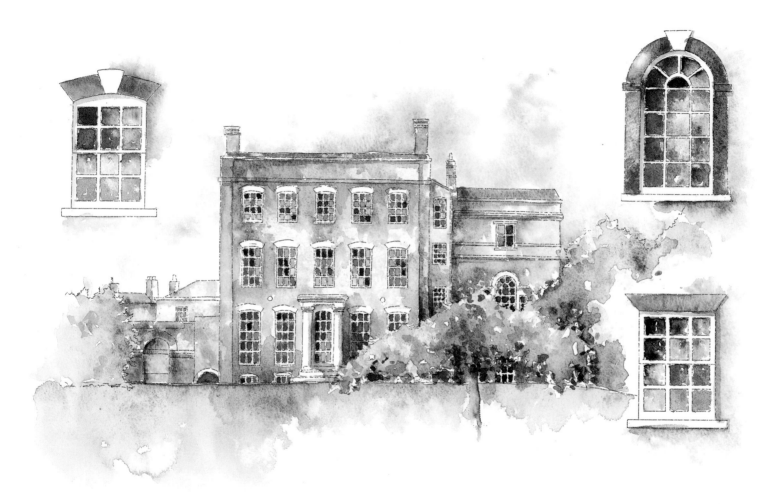

*Figure 14*

related geometrically to the others, and each pane in the window was of the same proportion. Georgian builders were not fond of balconies, but Regency developers added fashionable balconies with flamboyant wrought-iron decoration later on.

———————— • ————————

## FIGURE 14

Georgian town houses are an absolute delight to record in watercolour. As is often the case, in this example (page 43) the originally symmetrical building has had additions built on over the years — not always a bad thing as a little asymmetry can make for a more interesting composition.

In my opinion, the most attractive feature of these buildings is the wealth and variety of windows. Positioned round this sketch are several studies of the types of windows you are likely to see, all of which were included in the extensions built on this particularly imposing town house. Both the sash and the Venetian window are highly characteristic of the Georgian sense of visual order. The key to recording them is to look at the brick surrounds. The white woodwork of the window frame tends to emphasize the brickwork by contrast. The slightly arched top, with or without keystones, the flat top or the all-embracing surround are an intricate part of the building and can help to add visual interest to a flat wall, as well as making the window appear to stand out more.

## FIGURE 15

The sketchbook study I have chosen to illustrate the method I use for painting windows is a fine example of a Venetian window taken from a grimy City bank. The line drawing (Fig. 15a) was easy — total Georgian symmetry. One straight line through the middle was all the assistance that was needed. It is worth spending a few minutes practising drawing curves and semi-circles. Never start to draw the curve of a window at the top, drawing one half of the curve and then the other, hoping that the join won't show. It will! Worse, the curve will probably appear to be arched, with a slight point to it. The line of a curve needs to come from the straight upright, with two-thirds of the curve completed before you stop and work towards your broken line from the other side. The two lines do not need to actually join. A slight break to the side of a curve will rarely be obvious, and the human eye will make the join for you.

Having completed the drawing, with double lines for the glazing bars (assuming they are white, of course), some paint can be introduced. The first

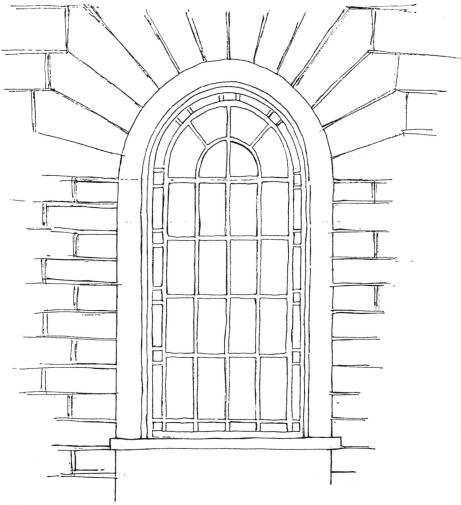

*Figure 15a*

stage (Fig. 15b) was to establish an under-coat for the decorative stone in which the window is set. This involved washing a mixture of Yellow Ochre and Burnt Sienna onto dampened paper, using a wet medium brush.

While this was drying, I began to mix the paint for the window (Fig. 15c). This was made with a combination of Prussian Blue and Burnt Umber, and applied with a dry medium brush. Much care was taken to ensure that all the window panes were not painted with the same tone. Window panes are rarely set into their frame at exactly the same angle, especially in older windows where the differences are often clearly visible, and consequently reflect light at different angles. There are no rules for this. Simply record what you see. The darker panes were painted first, mixing a little more water with the paint to complete the lighter panes.

The study was completed by the addition of a murky wash to add texture to the stonework and shading to the window (Fig. 15d). The method used was to dip a small wet brush into the remaining paint mix used for the glass. This was applied to the inside edge of the window

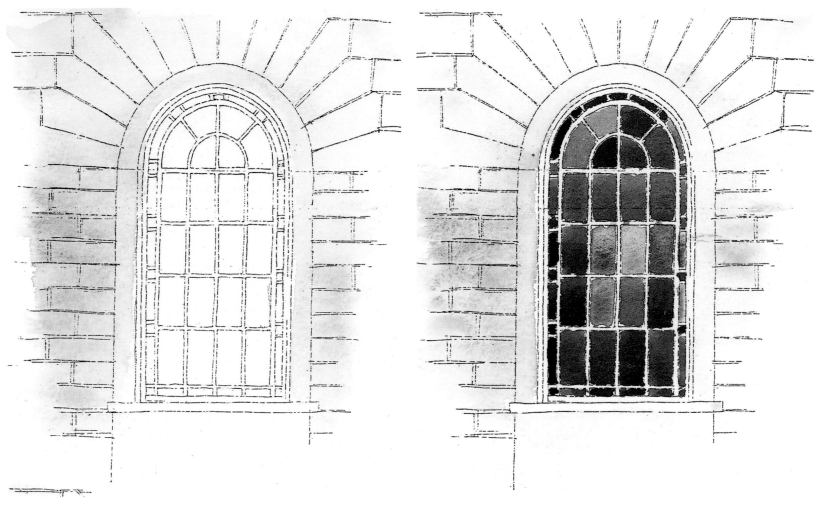

Figure 15b

Figure 15c

and 'pulled out' across the stone. Applied with a very wet brush, the paint will tend to run and form its own shapes. If these look good to you, then leave them. If not, blot them out quickly with kitchen roll and try again. As I have already mentioned, this blotting technique can help add texture to an otherwise dull wall. The study was completed by painting in the recesses of the stone with a small brush, used dry for paint control.

—————— · ——————

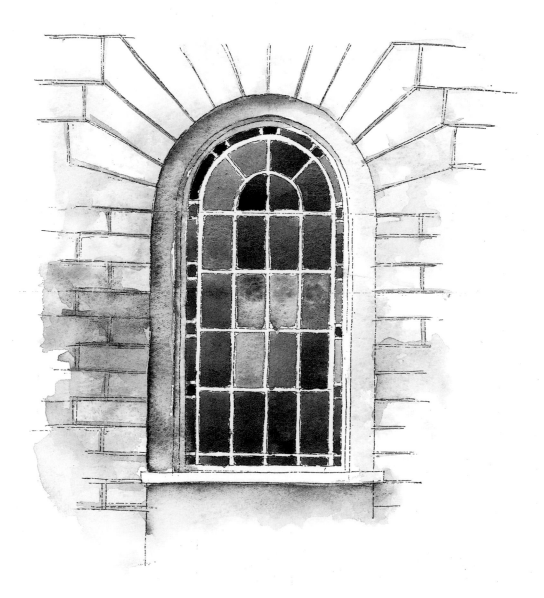

*Figure 15d*

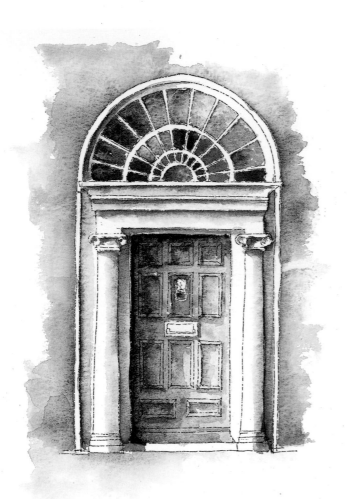

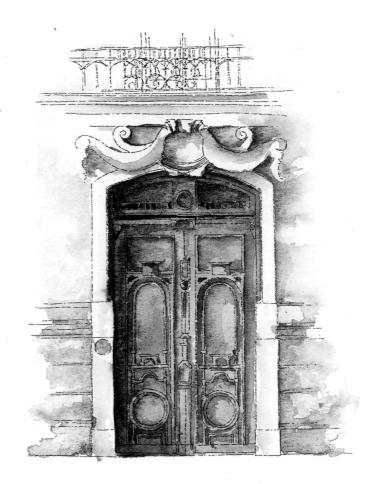

*Figure 16a*

*Figure 16b*

# FIGURE 16

Another great feature of the town house is the grand, imposing doorway, designed to inform all those entering of the status of the owner. For the artist, doorways offer two different areas of interest. The door surround, or porch in the more extensive varieties, may consist of full columns, relief columns, carved ornamental decoration and/or fanlights (Fig. 16a), all of which will cast shadows downwards and, more often than not, to one side, depending on the direction of the light. Then there is the actual door itself (Fig. 16b), often carved or moulded with indentations, raised woodwork, panels and, again, sometimes with fanlights set into the wood. All of these features when recorded in relief will create light shadows. Sometimes the panels will recede into the door, sometimes they will be raised – but always look carefully and note where the shadows are.

Fig. 16c is a very good example of the variety of features found in this French doorway. The ornamental decorations at the top of the façade were fun to record. The fanlight and wrought-iron

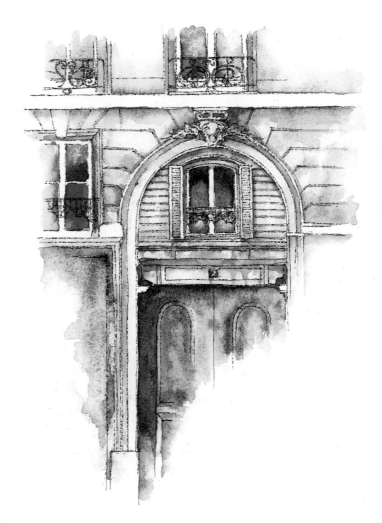

*Figure 16c*

49

railings add a visual break to the stone-work, and the door itself had some complementary curves in the woodwork. But the greatest joy with this doorway was capturing the grimy, rusting texture of the stone in watercolour. This was achieved by much washing and blotting. Several applications of watery ochres and umbers were washed onto the paper with a large brush, which will hold more water, and allowed to run and bleed freely, blotted only occasionally to recreate the patchy texture of old stone and stucco. As always, special attention was given to the recesses and raised ridges to determine shadows and highlights.

As a final note, look out for interesting or different peripherals. Door knockers can be very attractive, as can ornate lamps and house numbers.

So these are some of the aspects of urban architecture you are likely to encounter when looking for sketching or painting material on town or city streets. Some aspects will serve as sketchbook material, others will tempt you into devoting the time to a full-scale painting. But all are of equal value and, hopefully, equal pleasure.

———— · ————

# FOUR

## CITYSCAPES

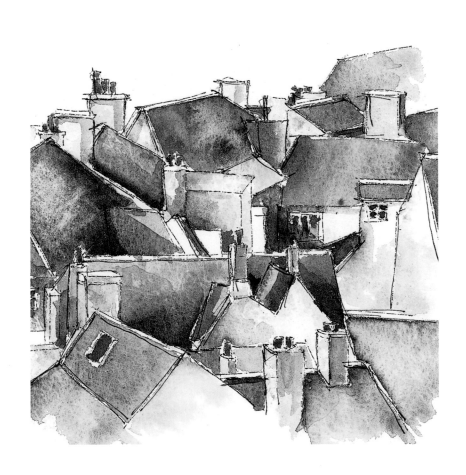

# CITYSCAPES

## FIGURE 17

Having concentrated so far on either single buildings or filling a sketchbook page, it is now time to expand our horizons and examine the wider aspects of painting in towns and cities. Occasionally it can be most enjoyable to catch a glimpse of sky, or to view the urban landscape as a whole rather than as a series of fragments making an incohesive pattern.

This picture (finished painting on page 57) is an example of the wider view of urban architecture, and also of some seasonal sketching. This Georgian terrace, one of the first built in Britain, is obscured from May when the cherry blossom is in full bloom through until October when the autumn leaves finally start to fall. Then it stands exposed against the threatening winter sky.

The first stage here (Fig. 17a) was to establish a line drawing, making sure that

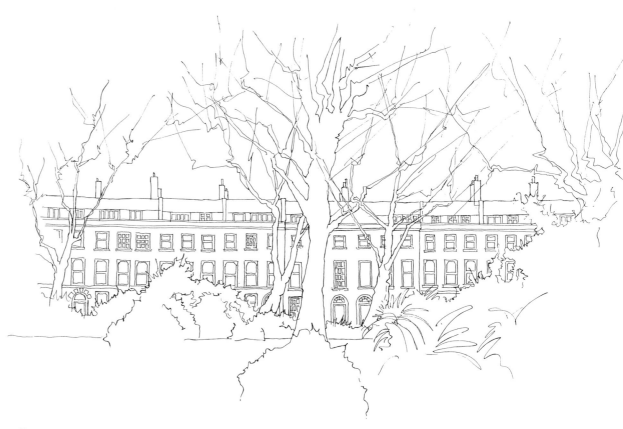

*Figure 17a*

the long lines of windows maintained straight, parallel positions. The composition is broken by the starkness of an imposing, barren tree positioned slightly off centre, filling what would otherwise have been a visually vacant foreground.

Having completed the 'anchor' for this picture, it was time to give some consideration to the sky. One of the beauties of watercolour is that it enables the artist to capture a passing moment, the mood of the day or the prevailing atmosphere with a few washes of carefully mixed colour. With dark clouds building on the horizon, emphasizing the lighter clouds in the middle, this sky was an exciting sight. It was recorded by dampening the sky area with a very wet wash brush, not worrying about the branches of the trees; the sky colour would serve as a sound colour wash or undercoat for these also (Fig. 17b). Before the paper had dried, a mixture of Prussian Blue and Burnt Umber was mixed and applied with a medium wet brush. This was not applied with a sweeping brushstroke but more with a couple of 'dabs', appropriately placed, allowing the paint to bleed on the damp paper. This could then be blotted with kitchen roll to create

the cloud effect, taking care of the background within a matter of minutes. As the sky will determine the mood of the day and subsequent lighting conditions, so the colour that you have mixed for the sky helps to develop the overall tone of your picture. So don't wash or clean it from your palette. Whilst the sky was drying, the paint for the rooftops was mixed by adding a little more blue to the existing sky colour. (It wouldn't do to paint the rooftops while the sky was still wet, as an unwanted bleed or two would have taken place.)

The wet slate roofs stood out well against the dark winter sky (Fig. 17c). No bleeds were required, so the paint was applied with a damp medium brush — dampened to ensure a free flow of paint, but not loaded with water to create a deluge. The patchy texture of the damp weather-worn brick of this long, elegant terrace was, like the sky, achieved by washing and blotting. Unlike the sky, however, more control was required in the application of the paint in order to leave the white window surrounds unpainted. This I did by loading a small brush with the mixture of paint that was already in the palette (the sky/roof mix-

ture) and adding a fair amount of Burnt Umber, then applying it to the previously dampened area. Like the roof, the paint did not need to run but to 'expand' within its defined area. It could not have been blotted effectively if the paint had been applied to dry paper, as it would have been absorbed much too quickly. The light cast from a strong winter's sky onto old brick can be a most appealing sight. These highlights were quickly blotted and left to dry thoroughly in the following minutes.

While we are considering the effects of light, it is important to examine the windows. Being glass, and consequently transparent, windows have no colour. The only way we can record them is by observing the colours and images that they reflect and painting these. In this particular picture, the original sky colour was used but intensified a little, then carefully applied to the appropriate places. The final touches to this section were to run a dark wash underneath the eves, overhangs and pediments to suggest the ever-present shading.

This painting could not, however, be completed without special attention to the foreground (Fig. 17d). The gardens

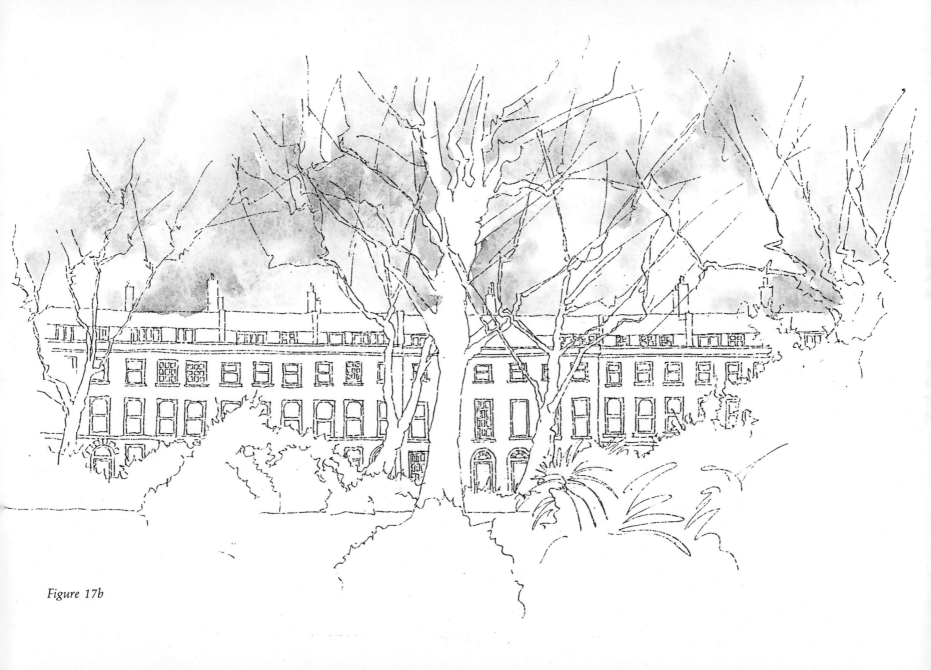

*Figure 17b*

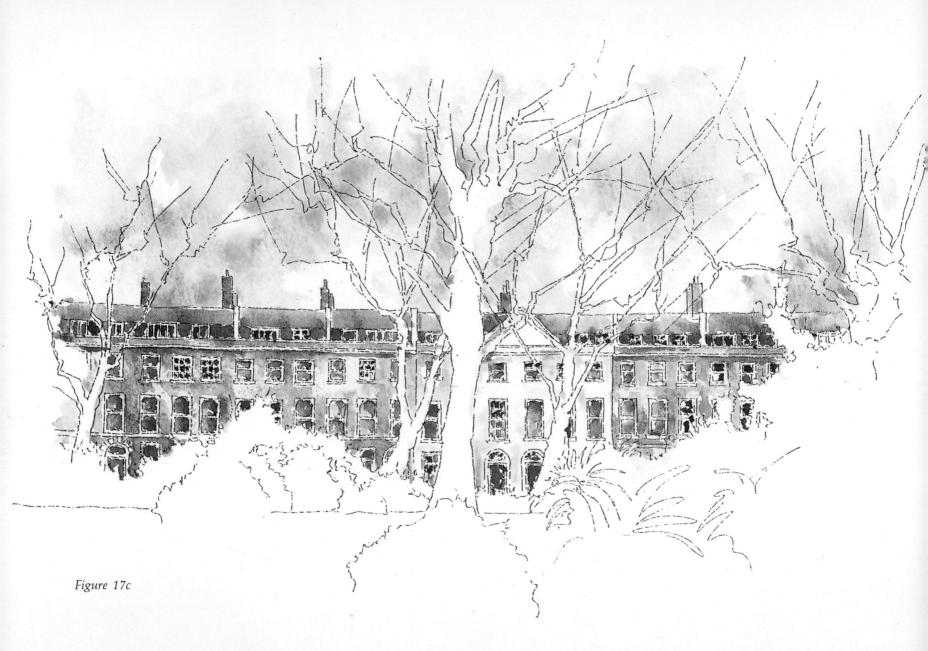

Figure 17c

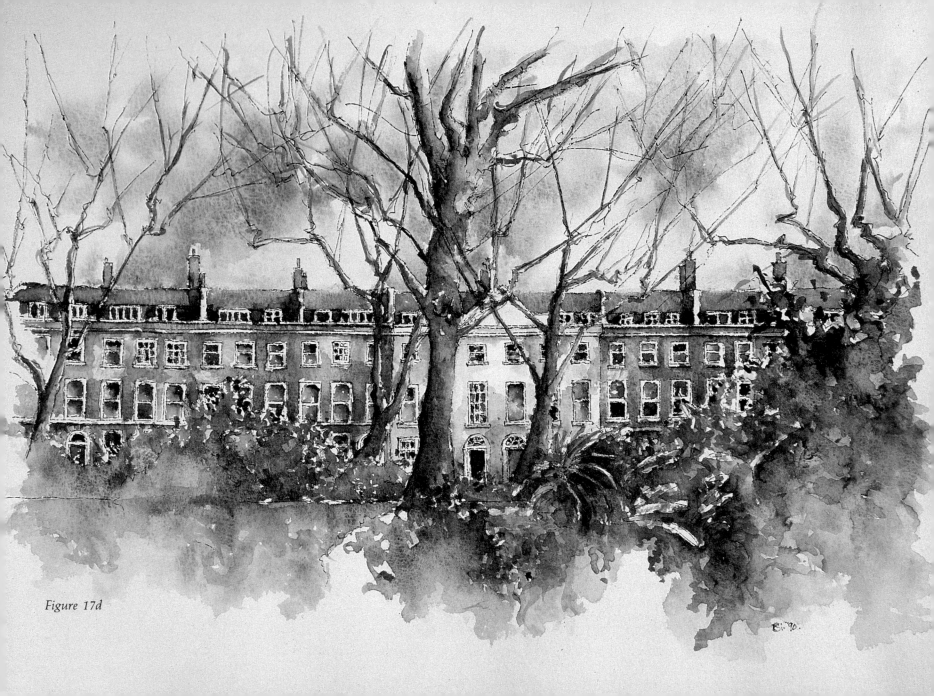

Figure 17d

that sat peacefully in the centre of a quiet square showed every sign of having survived a long, wet autumn. The greens were deep, but not as fresh as in summer, and the whole scene was one of naturally overgrown anarchy. The autumnal ochres still graced the ground, oozing moisture. The greens were painted with a lot of water and several washes. The basic mixture was Sap Green, Burnt Umber and a little Yellow Ochre. A variety of colours and tones were arrayed, with a little organization. The farthest rows of shrubbery running along the length of the garden perimeter were painted with a little more water than the foreground, for two reasons. First, the more water mixed with a colour the lighter the tone will be, giving a visual effect of depth and distance. Second, it allowed a painter's 'trick' to be introduced. By using a large, very wet brush (plain water, no colour) it is possible to literally 'pull' down the colour from the bottom of the foliage to create a sodden-looking foreground. This also fades out the foreground, eliminating the decision of where to end the composition.

The subject of where to finish a painting is almost as difficult as where to start! As you will notice, I rarely work within pre-defined boundaries, starting in the centre of the sheet of paper. This allows me the opportunity to extend my paintings upwards, sideways or downwards, depending entirely on how I think they look best. Your foreground will usually end about 2 m (6 ft) away (minimum) from your feet, but always allow yourself the option of extending this.

Finally, the trees. These were painted with a mixture of Burnt Umber and Yellow Ochre, using the water that was by now blue. This mixture was applied to the shaded side of the tree and, again, pulled across to the lighter side, with a little blotting just for effect.

———— · ————

## FIGURE 18

This painting of Les Halles, the converted old market in Paris, goes to prove that modern developments can make suitable subjects for artists. This glass cityscape was initially quite a daunting project, and I have no reservations about admitting that it was not painted 'on site' but at home, surrounded by a wealth of visual references recorded during a summer visit.

The main priority in beginning this picture was to ensure that the initial line drawing was correct and accurate. With so many visual planes crisscrossing and intersecting across the composition, it would have been very easy to have confused the line structure of the middle ground and background. It did, however, turn out to be quite a simple two-point perspective construction — it just had lots of bits and pieces to be fitted into it.

The entire vista over Les Halles can change dramatically with the weather. As mentioned earlier, glass is colourless — we only see it when it reflects colour. With glass in such quantity, all that could really be seen were reflections — reflections, that is, from the sky. A sunset can produce

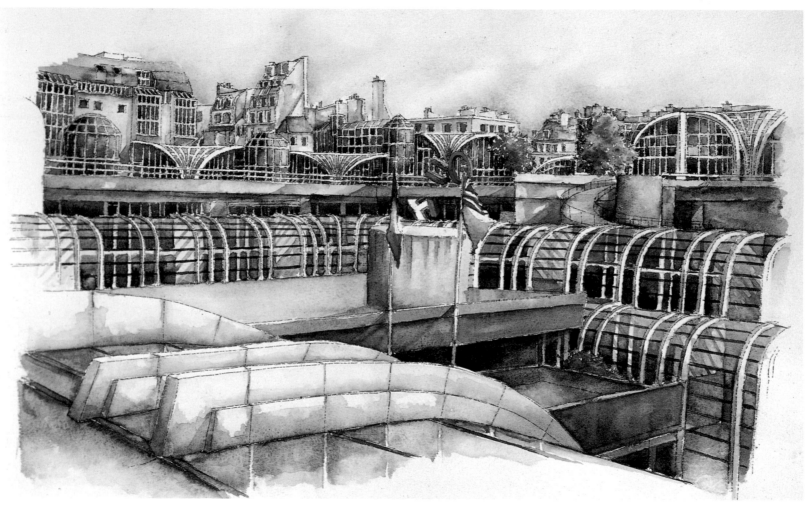

*Figure 18*

a kaleidoscope of pinks, oranges and reds, shooting out in all directions as the rays bounce from glass sheet to glass sheet. On the slightly overcast, humid day when I gathered the references for this painting, the glass structures were reflecting only the blue/grey drabness of the sky.

This picture was painted with much care, using very few washes as a great deal of control was required to leave the supports for the glass tunnels white. This type of accuracy will appeal to those with a specific interest in architectural recording. It was painted on relatively smooth paper.

———————— . ————————

## FIGURE 19

This painting of some of the new glass tower developments of London's infamous Docklands has much in common with the painting of the glass domes and tunnels of Les Halles. There are also some fundamental differences. The shapes of the buildings lend themselves to the simple box construction method (see page 23) and, again, the middle ground is a 'hotchpotch' of intersecting planes, angles and shapes (Fig. 19a). One difference arises here. This geometric view is enhanced by the sharp shadows that fall across buildings diagonally from right to left (Fig. 19b). The sun was brighter in London than Paris and heightened the shapes, giving visual weight to their lines and forms. The method used for recording these was first to paint all of the windows. Only when they were dry were the shadows introduced. A neutral tone taken from the glass, sky and river undercoats was loaded onto a wet medium brush and 'pulled' diagonally along the lines of the shadows, following their breaks and kinks as they fell. Using this technique means that a little of the already dried paint from the windows

may well be reconstituted and will bleed into the wash. But, as we know by now, this is not necessarily a bad thing as it may well add a little visual variety by its irregularity.

The other main difference is in the foreground as this involved my favourite technique of washing and blotting. The rusty hull of the old tug, the reflections of the concrete bank and the reflections in the river all required several applications of water to encourage and develop bleeds. The colour in the water around the hull of the boat was achieved by wetting the immediate paper and applying a mixture of red and Burnt Sienna to the rusty-coloured strip and leaving it to dry. This allowed the colour to bleed downwards where it was required to create the reflections of the colour in the water, but prevented it from bleeding upwards, where it was not required, into the main bulk of the ship's hull. This had previously been treated to a few washes of red and Burnt Sienna to create an impression of metallic ageing. The ochres on the concrete wall were 'pulled' down into the river in a similar way. Finally the entire foreground was treated to a series of downward washes, using neutral tones

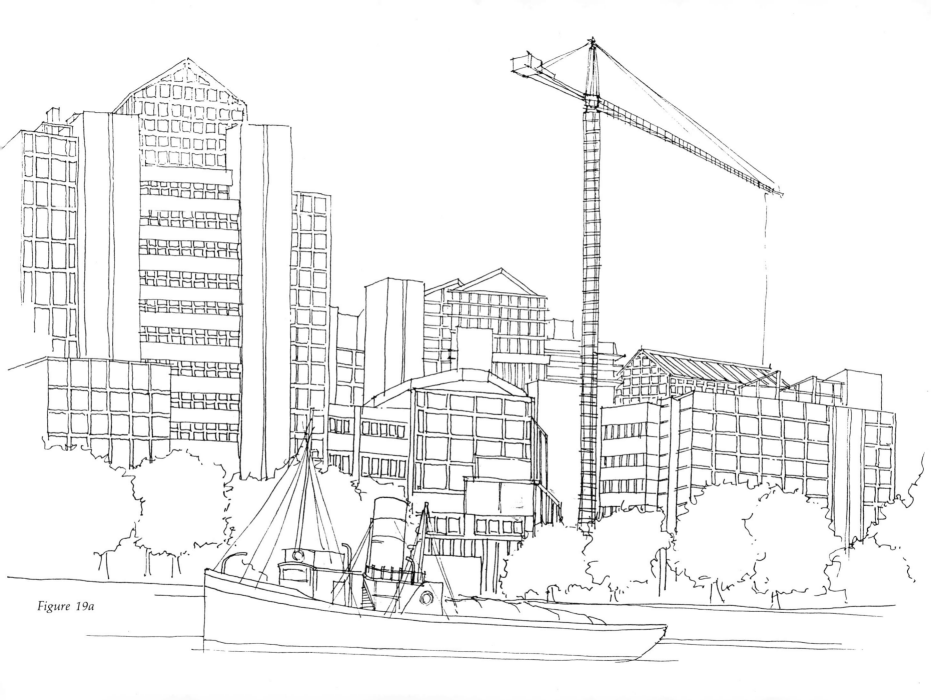

Figure 19a

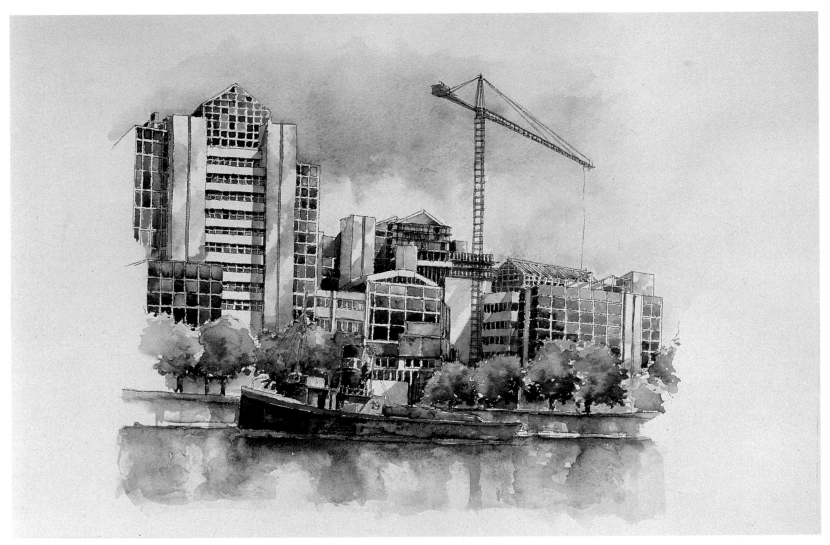

*Figure 19b*

from the remnants of the palette with much water and several sheets of kitchen roll.

The common factor between Figs. 18 and 19 is the flash of colour in the middle ground. In *Les Halles*, the giant plastic letters suspended amongst the concrete and glass break up the blues and greys with a flash of red and green. In *London Docklands*, the vertical flash of colour provided by the tall crane serves the same purpose, using a minimal amount of colour, strategically placed, to liven up an otherwise grey composition. However interesting a linear composition may be, a little sharp colour is always worth introducing.

As artists, we have the rare privilege of selection on site. This is something that is not available to photographers. We can choose to leave out visual obstacles, or features that we feel would not be in keeping with the overall tone of the composition. This is all very well if we simply choose to produce pleasant pictures. But if we also wish to chronicle the age in which we live, we may sometimes have to reconsider our prejudices against industrial machinery and construction equipment.

*Figure 20a*

## FIGURE 20

As I mentioned in the introductory section on perspective (page 23), you will usually be looking up at rooftops in towns and cities. As the painting of Les Halles proves, however, this is not always the case. Occasionally it is worthwhile trying to find a vantage point where you can look out over rooftops. The sketches in Figs. 20a and b illustrate these different views. Fig. 20a examines an unusual set of rooftops from the ground. You cannot see into the chimney pots and the tops of the roofs are not visible either. The two-point perspective technique has been employed here and the picture plane is reasonably flat. Fig. 20b is a sketch taken from a high vantage point looking down onto the grey slate roofs of northern England. This patchwork of blue and grey tones required some careful observation in order to differentiate between the two sides of the same roof. This was achieved by making sure that the side on which the sun was shining was lighter than the shaded side, and that the shadows were reasonably well pronounced, including the chimney stacks and pots.

*Figure 20b*

# FIGURE 21

This painting illustrates the appealing and picturesque qualities of 'run-down' backstreets in a small town in northern France, and the technique of looking up a set of steps or an inclining alleyway or slope. I chose this unremarkable alleyway for its light and shade rather than its architectural interest or its colour values. The heavy shadows cast by the high walls on the lefthand side form a marked contrast to the highlights on the very top background building, where a few shafts of light break through the surrounding buildings. The trickle of light creeping down the steps had an instant appeal. The patchy textures of the walls displayed a good range of tonal values, recorded with much wetting and overlaying of ochre washes.

The key to creating the illusion of looking up an alleyway or set of steps is to 'frame' the steps with narrow perpendicular lines, in this case the steep walls of the flanking buildings. Then, create a flash of interest (light or colour) at the top of the incline. This automatically leads the viewer's eye immediately into the narrow area of interest up towards the

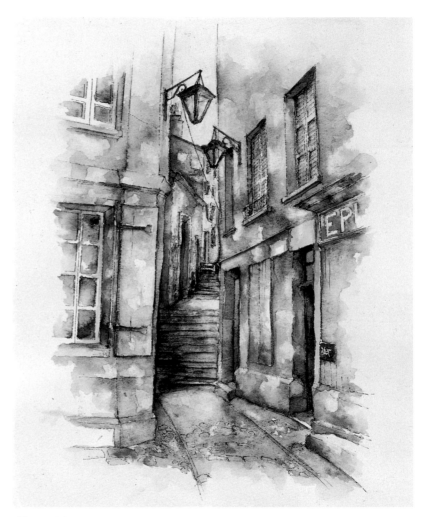

*Figure 21*

top. The viewer has then made the journey along the steps without giving the matter a second thought. But this is always the way with painting – suggestion is much more effective than overt realization.

These then are the techniques and systems that I employ when I am searching for scenes rather than details to draw and paint – 'cityscapes'. A vast array of sites can be found if you are prepared to work out of season or to climb to vantage points. Towers, castles, churches and friends' windows all provide high viewpoints from which you can generally sketch for a few minutes before becoming a public obstruction.

Finally, do not dismiss new developments as barren shells created by uncontrolled planners with a grudge against their classically inclined tutors. Many de-regulated areas hold some wonderful sites within their windswept complexes. You just need to find a different 'perspective'.

———— . ————

# FIVE

## HIGH STREETS

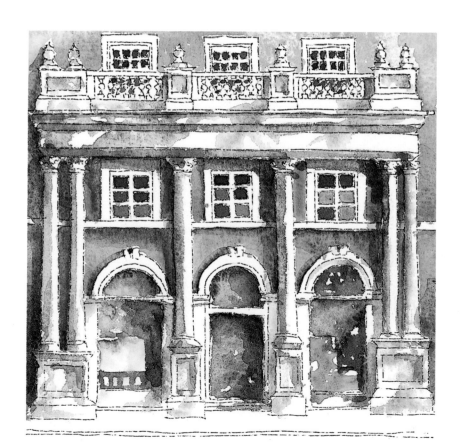

# HIGH STREETS

The local High Street might not be the most instantly appealing choice for a painting site, but it may contain some remarkable features, in terms of both architecture and colour.

The origins of many High Streets lay in their development as alternatives to outdoor markets. Town residents began to develop the fronts of their houses to attract potential shoppers inside. The embryonic shopkeepers would sit outside and entice the bargain-hunters. As competition grew, so did the quality of the signs and façades.

The average High Street will have developed over a period of many years, and the buildings that line it will bear witness to this. From its humble origins as a rural cart track, the High Street has developed as a centre of trade, surviving the highly ordered Georgians and the excesses of the Victorians, with their love of the 'High Gothic', to emerge as a diverse mixture of styles.

## FIGURE 22

The façades of today's modern commercial buildings, designed to catch the eye of the shopper, often prevent the rest of the building being seen in its best light. Several storeys of elegant architecture frequently exist above the optimum visual sign level.

Admittedly, this is probably one of the most difficult of environments to work in. By the very nature of their existence, High Streets are centres of shopping and full of people on the move. Sundays are probably the best days to record these sites without being trampled underfoot (public holidays are another good time), when the vast majority of shops are closed for business.

Here I set out to produce a panoramic view of a provincial High Street (see page 74 for the finished painting). The human eye only has a limited angle of vision from one fixed point. This particular panoramic view did not evolve from looking to the left and then to the right from a fixed point as this would have produced a 'wide-angle' view, with contradicting angles and perspective. It is the result of recording a set of buildings, then moving along and recording the next set, and repeating this procedure (Fig. 22a). The set was then lined up and a panorama produced that was outside the natural angle of vision, but not visually confusing.

Initially I chose an appropriate High Street which was awash with Edwardian and Victorian architecture and contained much variety. Having made my choice of subject, a few visual divisions were needed. I decided upon the centre of the line of buildings as a starting point and divided them up to the left and right proportionally. These buildings then had to be recorded in a sketchbook for further reference. One of the most important considerations was to ensure that each

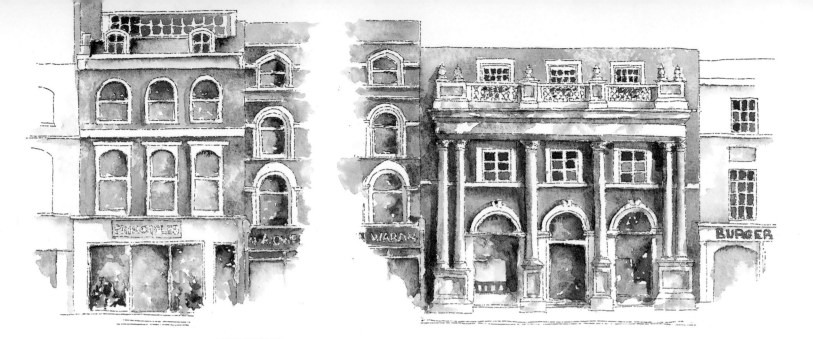

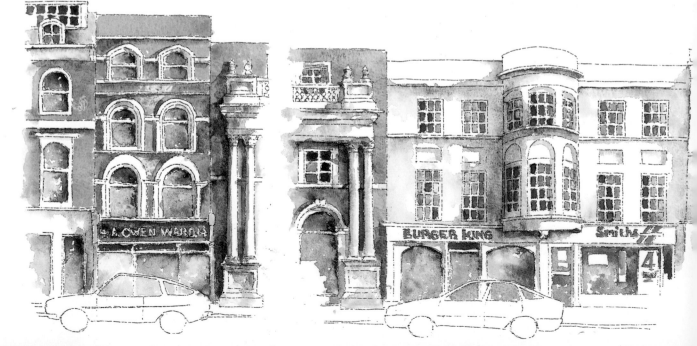

*Figure 22a*

building painted contained an overlap of part of a building already recorded. This technique is invaluable if you are to fit all of the pieces together, jigsaw-style, when you return home to your studio base. Probably the hardest part of producing these working sketches is keeping them all to scale. I tend to use a common baseline and to measure the assorted heights against each other by way of crossreference. When these are com-

pleted to your satisfaction, they can be carried home for further development.

Using two ruled pencil lines, for the base and the standard roof height, I then set about producing a line drawing of the entire set of buildings. Starting at the centre and working to the left and right, I fitted the scene together, piece by piece (Fig. 22b). It may not be a bad idea to do a trial run before committing yourself to the finished drawing.

When you are ready, transfer the picture onto watercolour paper that, in this case, would generally be stretched (see page 18) – do the drawing after the paper is stretched. You can now proceed as with any other watercolour painting, by establishing the background colours (Fig. 22c). In this case, a tried and trusted mixture of Burnt Umber, a little Burnt Sienna and a touch of Prussian Blue to moderate the tone in keeping with the

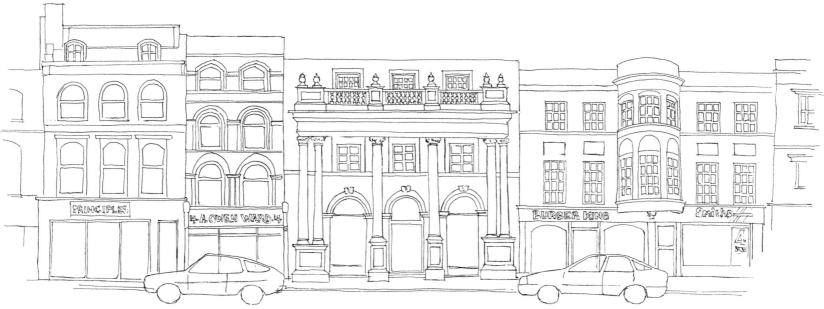

*Figure 22b*

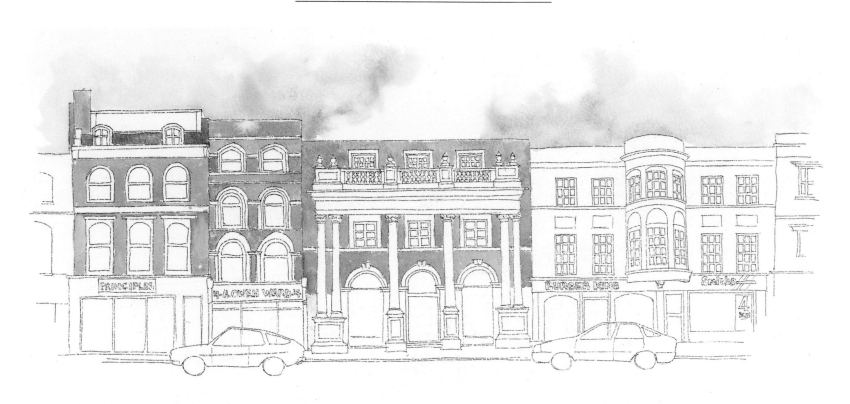

*Figure 22c*

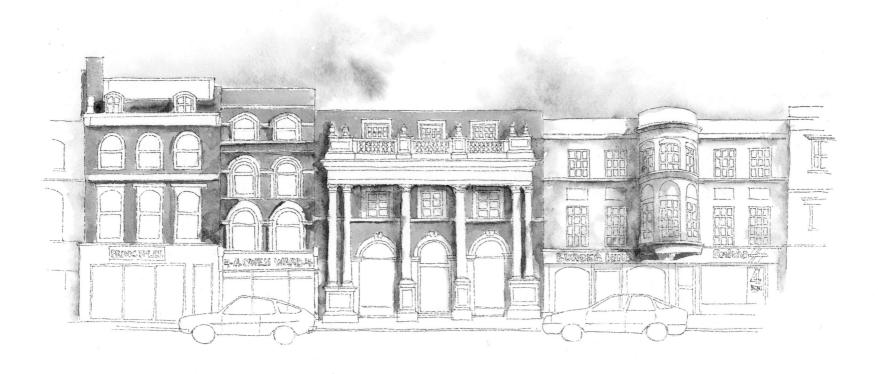

*Figure 22d*

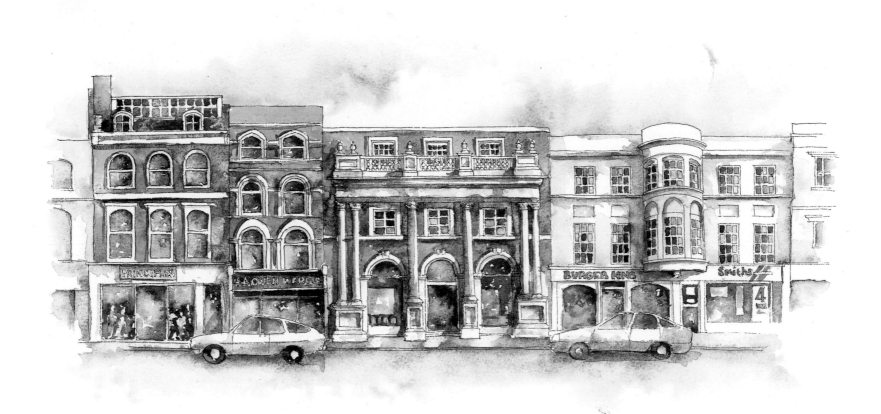

*Figure 22e*

sky was introduced for the building fabric. The brick tones were painted with reasonable care with a medium brush on dry paper to avoid unwanted runs or bleeds. There were many white balconies, ledges and pieces of architectural decoration in this composition which needed to stay white.

I felt that it was important at this stage to introduce some 'body' into the composition, and so began to establish the main bulk of the shadows and shading (Fig. 22d). Only the basic shadows were painted in – the details and curves on the columns came later. One of the main features of this composition is the large white semi-circular bay section of the pure white building on the far right-hand side. This was an opportunity to use shading to emphasize the graceful sweep of the curve, both on the bay and as a shadow falling onto the flat wall. It was achieved by creating a shadow tone, using the residue paint left over from the sky and brick mixture, heavily weighted with the sky tone. This was applied with a medium brush to dry paper along the lefthand edge of the bay. Before it had time to dry, the paint was 'pulled' in a sweeping curve round the bay with a wet

brush. Shadows on curved surfaces are generally graduated as there are rarely sharp angles or edges to create them, and this technique helps to create this effect. As the paint is 'pulled' out with a wet brush, the colour becomes gradually watered down. When dry (watercolour paint always dries lighter than it appears when wet), the tone appears graduated. This technique could also be used to good effect with all the other shadows in this composition, recorded on a day when the natural daylight was not strong enough to create shadows with sharp 'edges'. A little washing and blotting gave extra tone to the buildings.

The painting was brought to completion (Fig. 22e) by developing the windows, signs and other urban peripherals – cars, etc. The shading needed to be extended to cover all the indentations, protrusions, carvings and overhangs. This was done by carefully running a line of paint underneath the overhangs and, having rinsed the brush, 'pulling' the wet paint downwards, allowing it to graduate as it dried. A few colour bleeds in the windows completed this study of the type of architecture you are likely to find in your local High Street.

FIGURE 23

The sketchbook studies overleaf examine some of the features of the typical British public house. The elaborate nature of this style of architecture probably has its roots in its Victorian origins. These institutions have been copied throughout the world, and pubs can be found throughout Europe (especially the Mediterranean coastal resorts), North America and Australia. Their doors are generally highly polished and well constructed, often with brass attachments which call for a watery coating of Yellow Ochre. The windows, unlike many buildings of their age, do not have white window frames and glazing bars but instead will often be polished wood. The bow windows of this particular pub were recorded using the same technique as that described in the previous set of panoramic illustrations, only in a different sequence. Whereas with the white building in the panoramic view the shadow was painted before the windows, in this sketch I reversed the procedure. As the windows were dark and the wood was dark, it was not inappropriate to apply the shadow paint (Burnt Umber mixed with Prussian Blue in this case)

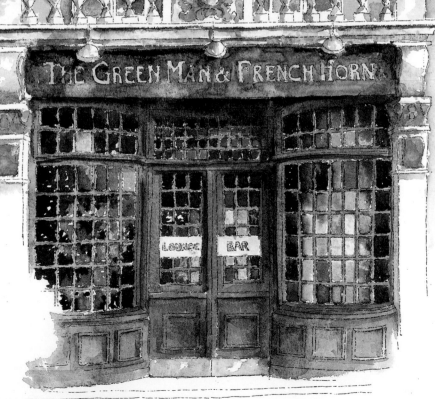

underneath the sign and, using a wet medium brush, to 'pull' the paint round in a gentle sweep. Even with thoroughly dried paint, the application of a watery wash on top will result in the dried paint reconstituting slightly, creating the subsequent bleed. I considered that this would not necessarily be a bad thing as it would allow the opportunity for blotting here and there.

A main feature of town and city pubs is their signs. Villages and country hamlets probably supported only one public house, making a sign or display of its name unimportant when they were first established. The cities, however, could seemingly support any number of public houses and, therefore, needed to assert their individuality to maintain and increase their trade. These are often easier to record than might appear instantly obvious, the chief reason being that a sign-writer has already done the planning and layout of the lettering for you. He will have worked out the spacing between words and the gaps at either end. I tend to establish the centre letter

*Figure 23*

and the first and last letters at the initial sketch stage, and then work backwards one letter, forwards one letter, until the lettering is complete. In this case, the lettering was lighter than the background but the colours kindly allowed me to paint on an undercoat for the whole sign that just happened to be the same colour as the lettering. A mixture of Cadmium Yellow and Yellow Ochre (just to tone down the brightness) was mixed and washed onto a slightly dampened paper to allow an even covering. This had to be thoroughly dry before the background green was applied, as no runs or bleeds were required. Using a well-loaded small brush, a mixture of Sap Green and the residue from the yellow undercoat was applied with great care round the letters, completing this set of studies.

————— . —————

## FIGURE 24

The painting overleaf of a small town High Street in Colorado, U.S.A. is a wonderful reincarnation of the old days of the American West, without being so tourist-oriented that myth takes over from the reality of history. The reinstated new façades sit easily with the genuine old. One of the most interesting features of this scene was the piece of urban decay on the wall above the County Jail. The original artwork painted on the wall had worn and was as faded and patchy as the plaster base that once supported it. It was the patchy texture that I found appealing as it lent itself so well to several wet washes which were allowed to find their own way, with only infrequent blotting. The occasional piece of worn lettering, half eroded by the ravages of time and the Colorado weather, made a subtle contrast to the boldness of the main wording, as did the other main feature of this painting. Positioned just off centre, vertically piercing this composition, is a bright red, unattractive old street lamp. Without this flash of colour, the composition would be considerably less interesting. Its placement bisects the potential

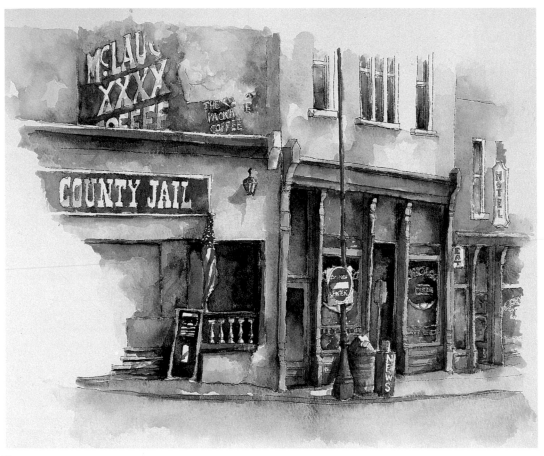

*Figure 24*

drabness of the faded wooden shop fronts, and its colour injects some life into an otherwise colourless composition. Once again, this is the beauty of towns and cities – everyday features can enhance almost any picture if considered carefully at the outset.

So these are some of the things that can be found in High Streets in Europe and America, if you take some time to look beyond the commercial façades. The architecture may be faded and cracked, but this may make for a more interesting study. High Streets are busy places and will always attract people and traffic, so you may have to fall back on your resourceful sketchbook to make a few notes for later reference. Alternatively, you may join the swelling ranks of 'rest day' painters who take to the streets when other people do not. However you choose to work, do not dismiss the local High Street because it is the place where you do your shopping – you may well find that it has much more to offer.

——————  ·  ——————

# SIX

# STREET LIFE

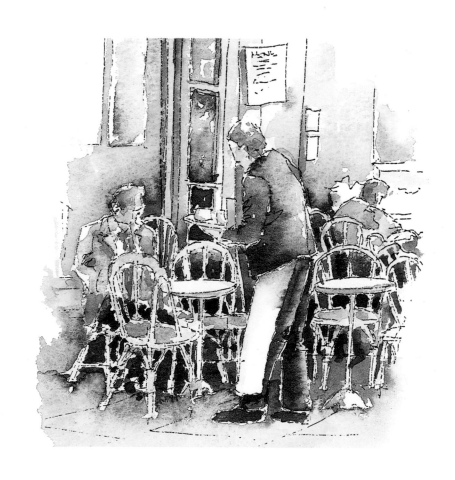

# STREET LIFE

The architecture and built environment of towns and cities can be great inspiration for the artist, but the overall atmosphere of these places cannot be recorded with total accuracy if the streets and pavements are devoid of human life. It is the people that make towns and cities come to life, both by day and by night.

Figure studies are harder to make than architectural studies – figures rarely stay still for as long as buildings! They often only put in a fleeting appearance as they move across your composition, but if it is the body and soul of cities that you wish to record you cannot allow them to pass unnoted.

It was only at the turn of the nineteenth century that figures began to appear in paintings in this manner. The advent of photography and the work of Nadar, the Parisian photographer, in particular had an important effect on the painters of the day. Suddenly they were able to freeze human activity in a single image. This ability to capture a passing second, and to halt people walking into and out of a composition in a snapshot view, impressed the artists who sat at café tables watching Parisian society pass by. The schematic approach to figure painting taught by the academics, where every figure's position, pose and demeanour were laid down formally in a rigid set of rules, was already in the process of being rejected. Photography helped to seal its downfall, and by 1900 paintings were starting to appear with people only half in the composition clearly about to cross the picture plane but frozen in a passing second.

It is probably much easier to begin to sketch figures without any concern for colour, or possibly even tone, at first – simply establish a shape with as few lines as possible. This is best done, in true bohemian style, sitting at a café table. You will have a seat, a table on which to rest and you should not be so conspi-cuous that you disconcert your subjects. The people you choose to sketch will also be seated. Doubtless they will move, shift and fidget, but they should remain more or less in the same place for a good few minutes. Start with a single figure, then perhaps a couple, and then move on to a composition, maybe considering the direction of their heads. Are they several separate individuals with little connection, or are they looking towards each other, making eye contact? These aspects are as important as the technical composition. Will your figures have a human element or will they be an extension of the architecture?

———— · ————

*Figure 25a*

## FIGURE 25

In this set of step-by-step examples, I have used a section of a painting only. I believe this allows the individual stages to be viewed with more clarity than if the entire composition with its human clutter were shown here. As in all cases, my first action was to make a quick line sketch (Fig. 25a), establishing the rough shape, size and positioning of the key figures. The line drawing is all the more important in this particular case as the chairs on which, and the tables at which, the subjects are sitting create visual chaos with chair and human legs crossing and intertwining, bisected by the vertical lines of the tables. A few confident pen strokes can help to bring some order to this scene. Incidentally, do not try to match the chair legs in the background with their appropriate seats, as they won't. Sometimes, when you are faced with a complex composition, and are simply trying to record the atmosphere of the situation, it can be counter-productive to become 'bogged down' with absolute accuracy. A sketch is a sketch, not a faultless photo-image.

It might be worth mentioning here that one good method of assessing whether a figure sketch is correctly proportional is to see if the head will fit into the rest of the body about five times – a rough but useful guide.

Having satisfied myself that the sketch included all the information I required, I set about painting. The first stage was to establish the underlying base, or undercoat, colours (Fig. 25b). In this particular instance, a straightforward Yellow Ochre wash was applied, serving two specific purposes. As the background was comprised mainly of wooden panels, a light wood colour would be perfectly appropriate. Possibly more important, the chairs were a lighter brown cane colour. Having painted these with the initial wash, they needed little more attention. The shadows and shading were eventually painted in between the background and the legs of the chairs, creating a 'negative' image, i.e. the foreground is lighter than the background. This process starts with Fig. 25c. Here the background colour is established by painting in the wood panels with a mixture of Burnt Umber and Prussian Blue, creating the darker shadows towards the base of the wall, highlighting the backs of the chairs in turn. On the lighter strips of wood running the length of the wall, the Yellow Ochre undercoat can be seen showing through. Next (Fig. 25d) the ground colour was painted in, reinforcing the light wooden chairs. This is an invaluable technique to employ when confronted with a composition where the foreground subject is lighter in colour and tone than the background.

This now left only the figures to paint. Being left with a set of ghostly figures set against a dark wood panelled background, it was easy to apply a quick wash with a small brush rather than to paint them gingerly or carefully. To maintain their lightness and their subsequent position in the foreground only a light colour wash was needed, 'pulling' the colour downwards so that any accumulation of watercolour paint would dry at the bottom of the figures – exactly where any shading would naturally be (Fig. 25e)!

Figs. 26, 27 and 28 (pages 88–9) all employ this technique of darkening the background to allow the light figures to take up their rightful place in the foreground of the composition.

*Figure 25b*

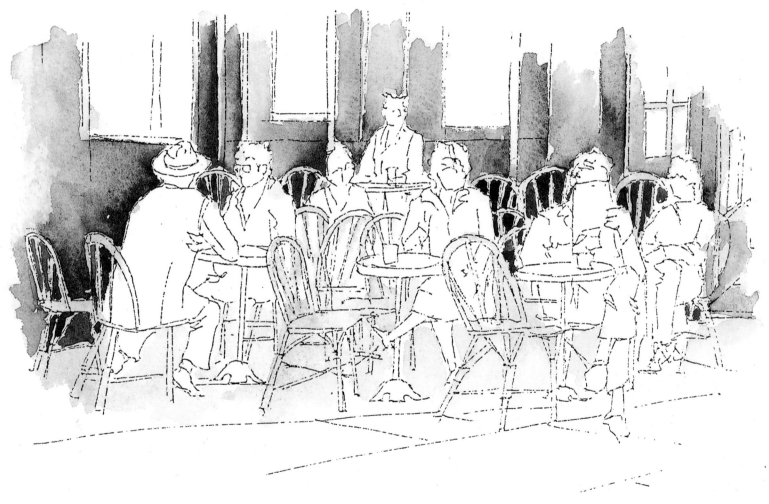

*Figure 25c*

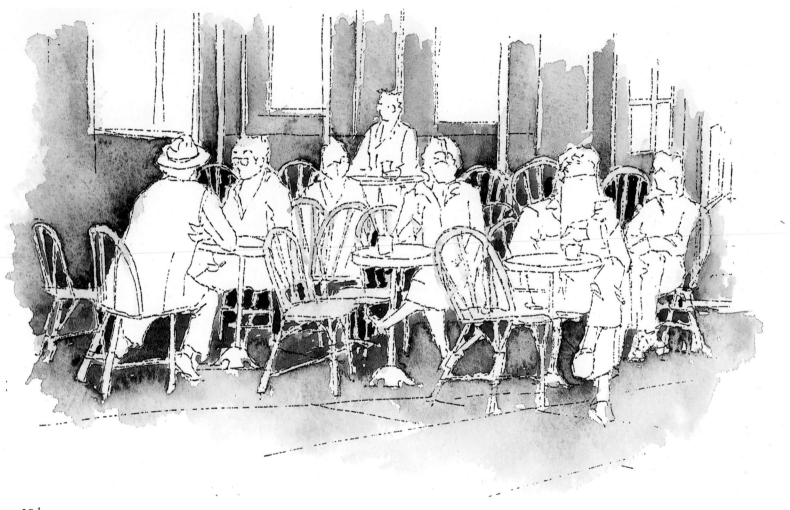

*Figure 25d*

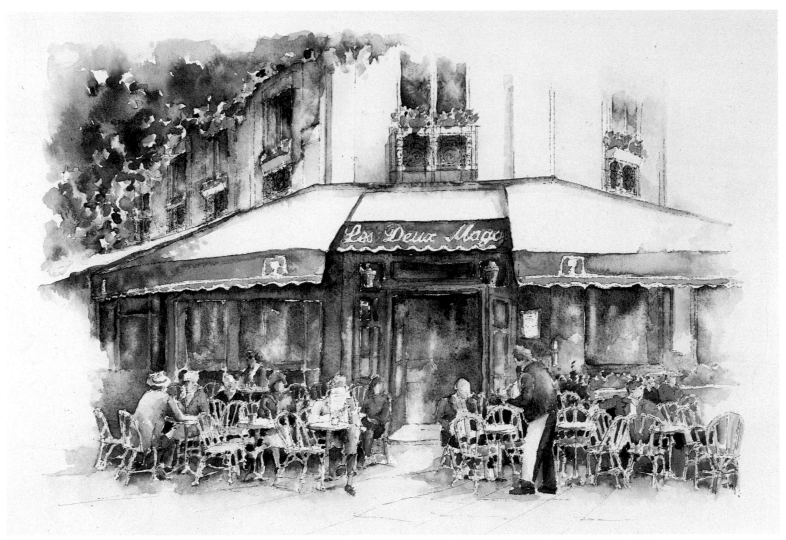

*Figure 25e*

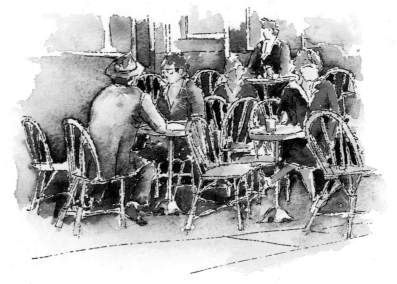

Figure 27

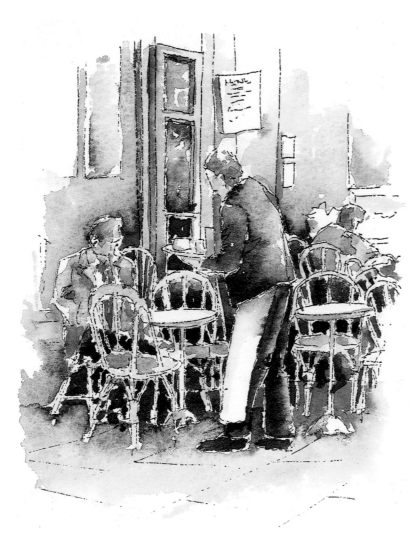

Figure 26

FIGURE 29

Sometimes human life needs to be included in a composition simply to give it some credibility. La Rotonde in Paris (overleaf) is probably the most famous artists' café in the world. It made a pleasing composition, with the wet road reflecting the colours and soft morning light casting dappled shadows on the warm stone walls. It would have been all too easy not to have included the 'No Entry' signs and the traffic lights, but where would the credibility of such a picture be without the trappings of twentieth-century life? There simply had to be people on the streets — they had every right to be there, and no right to be left out. It is here that the differences between urban and rural artists are evident. It would not be unusual for an artist to leave out 'No Parking' signs outside a thatched cottage or country church, and it could be argued that they were out of keeping with the environment. But in the heart of the city, where images of modern living are on the streets in strength, they become an essential part of the composition and need to be treated with appropriate artistic reverence.

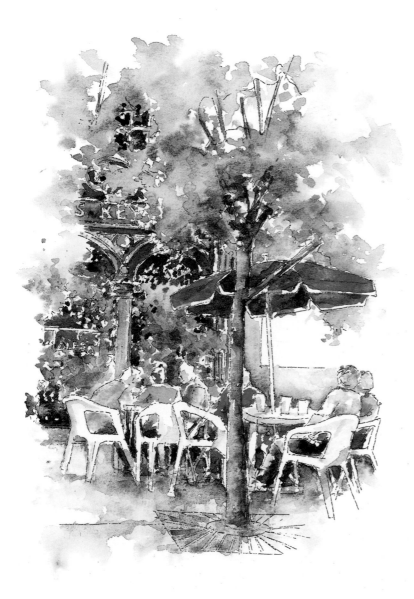

*Figure 28*

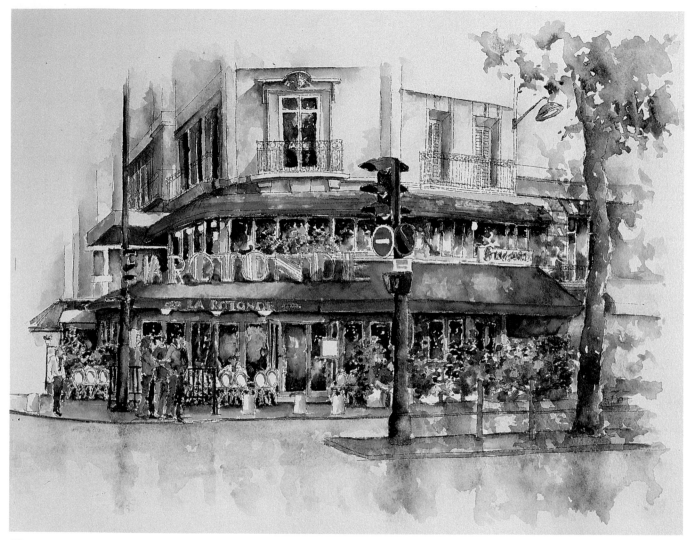

*Figure 29*

## FIGURE 30

This painting shows the new development in Covent Garden in London. This was as much an exercise in composition as it was in recording the brightness and bustle of a city scene. The imposing stone façade made a wonderful backdrop for the colour and activity of the flower stall and shoppers (Fig. 30a).

Although I could not (or, at least, I did not) arrange a group of figures on the far righthand corner of the composition, or request the figure passing directly through the centre to hold her position, a little thought was given to the structure of this picture. Having walked around the market complex several times and approached the front from several angles, I noticed a cluster of figures standing in a direct diagonal line running from the top lefthand pillar through the centre to the bottom righthand corner (Fig. 30b). They were also in the bottom third of a possible composition. A quick sketch secured their position. A composition incorporating these figures only might have been a little unbalanced, so I simply waited until someone crossed the scene and sketched them in at the appropriate point, creating

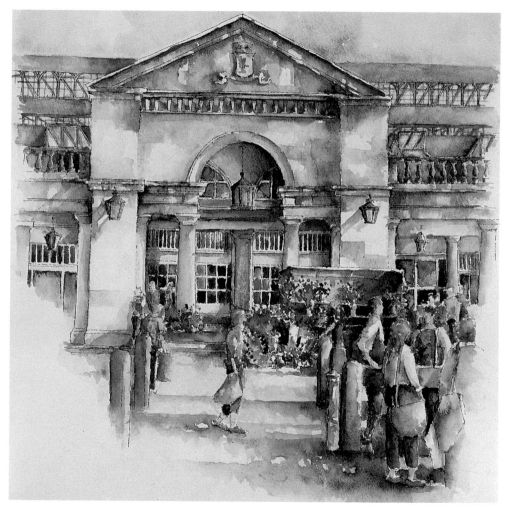

*Figure 30a*

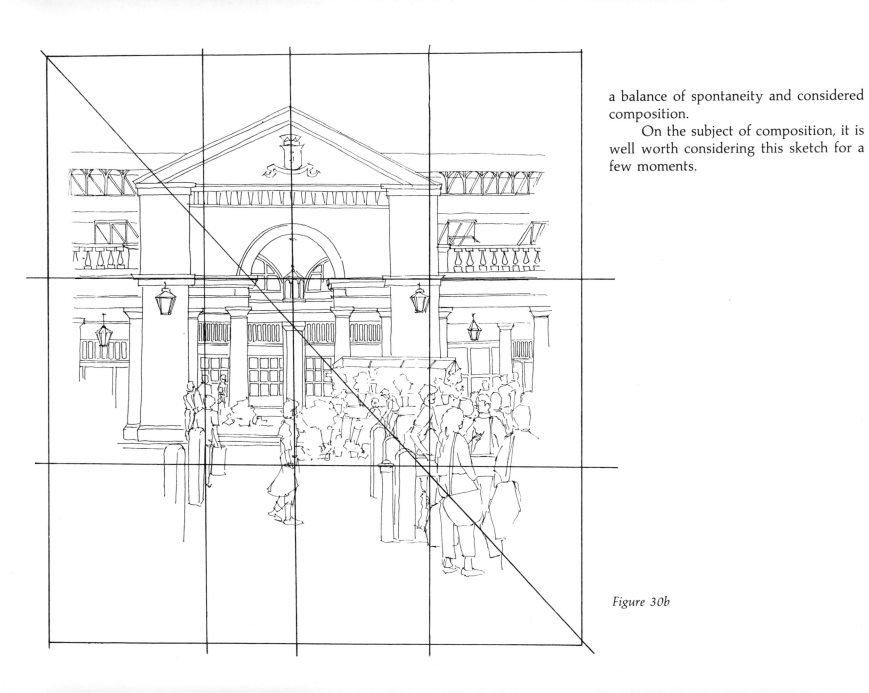

a balance of spontaneity and considered composition.

On the subject of composition, it is well worth considering this sketch for a few moments.

*Figure 30b*

# COMPOSITION

The entire business of composition is about arranging what you see on paper or, alternatively, looking for a scene that will look good when recorded on paper. It is about selecting interesting subjects that will create a visual balance when either drawn or painted. Much can be learned by looking at other people's paintings with a critical eye. How have they arranged the focal point of the composition? Have they used tone and colour to direct your eye towards it? Does the picture instil a sense of visual harmony, or does it disturb? All these questions are worth asking in order to establish your own sense of composition.

Traditionally, compositions have been based upon the 'Golden Section' principle, developed during the Renaissance. As was the norm for this period in history, a rigid and complex mathematical formula was conceived which would provide the artist with a framework that would achieve the optimum balance and harmony in the arrangement of the sections of any composition. Over the years, this has been watered down and simplified by dividing a picture plane into thirds and balancing the main parts of the composition – be they figures or colours – close to them. It is important to stress, however, that the vast majority of artists divide their compositions into approximate thirds using rough judgement.

In this particular illustration of Covent Garden, the areas of interest are based loosely around the vertical and horizontal thirds, with the focal point (the group of figures at the bottom righthand corner) also arranged around a dissecting diagonal. This diagonal makes a visual connection: the viewer's eye is automatically led into the centre, up towards the top left, reinforcing the geometry, which results in a more structured, visually pleasing picture. Anything below the bottom third is obvious foreground and will need to be stronger and more detailed than the area between the two horizontal thirds. This area is the middle ground, where colours may bleed and merge with less concern for sharpness and clarity. The top third serves as the background, which will generally act as a backdrop to the rest of the painting. I have included the centre vertical line for information only. There are no rules in composition which say you should never have your focal point in the dead centre of the picture, but it is generally best to shift it slightly to one side or the other.

To conclude this chapter, street life exists at all times of the day and night in our towns and cities, and people gather and congregate in all sorts of public places. Do not deny them their right to be part of your composition. A quick sketch will secure their position, complete with handbags, shopping bags, newspapers, etc. These are all part of the daily life of the urban environment and deserve to be recorded.

If you specifically wish to include people in your compositions, then go where they are most likely to be immobile. Travel terminals are always a good place; there you will always find people sitting waiting. All towns and cities have railway stations which, incidentally, often have a fascinating architecture of their own. Markets are also a good source of human activity, often set against a varied and colourful background. The shoppers may not stand still for long, but the stallholders will often hold a pose in their quieter moments that you can catch quickly. Of course, countries where the

café culture is alive and thriving are by far the best for capturing human activity — or inactivity. In southern European countries and others where the climate permits, outdoor tables are the best places for people-sketching, or simply people-watching.

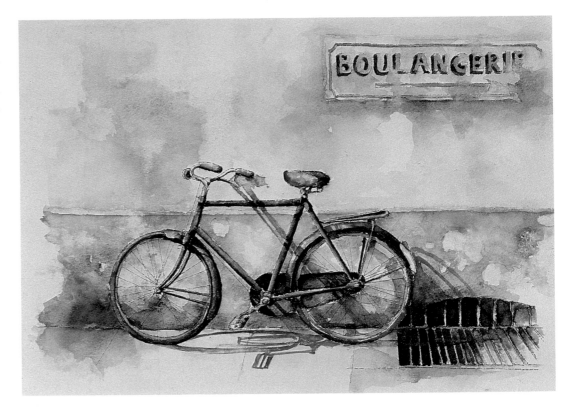

# SEVEN

## QUIET CORNERS

# QUIET CORNERS

Urban life is not all hustle and bustle. Either by accident or design (city-dwellers like to create personal spaces for themselves), if you look hard enough you will be able to discover quiet corners. The need to find these oases is imperative for those who live and work in large towns or cities, frequently in the middle of the most built-up and frenzied places.

Many of these quiet corners will be small, being in places where ground space is expensive and, consequently, at a premium. They may well be public, but sometimes private. Many urban homes have no gardens, or are built in a manner that results in several apartments sharing a courtyard. Those that have no garden will often utilize balconies, steps and entrances to their fullest potential. This is more noticeable in Mediterranean towns and cities where, perhaps more than anywhere else, a riot of colour hangs from the balconies. During the summer months especially, these are piled high with tee-tering terracotta pots full of geraniums hanging pendulous and fragrant. These are a pure delight to fill sketchbooks with and are even more interesting for the botanically minded.

## FIGURE 31

The painting overleaf is an example of how a simple scene can be an attractive subject. It is the result of two artistic elements. First, the interplay of reds and greens always has a strong visual effect. On the chromatic scale (the colour wheel), red and green are opposite colours and therefore 'set each other off' when placed directly together. Second, there is the interplay of dark and light between the foliage and the shadows that it casts. In some places the shadows are darker than the hanging ivy leaves; in other places, where the light has not penetrated so deeply, the shadows are lighter than the leaves. This is always the case when leaves are painted as light will fall in many different places with a range of intensity. To record this effect in watercolour, I tend to use a 'dabbing' technique. This involves dampening the whole area representing the foliage. Then with a medium brush I 'dab' a mixture of Sap Green and Yellow Ochre onto the damp paper to represent a section of the greenery that I have identified as being highlighted. This will bleed on the damp paper, becoming lighter towards the edge of the paint run. If this is carefully blotted just at the edge of the run, leaving the section underneath still damp, it will appear even lighter still. Next, a very strong paint mixture (using the same colours) is 'dabbed' under the blot; it will run downwards but will maintain its intensity at the top, creating a shadow effect. This 'dabbing' technique is one I use frequently when painting leaves, plants, and ivy.

*Figure 31*

## FIGURE 32

Where space is in short supply, or only concrete is available, city-dwellers usually manage to make very good use of free-standing pots. This next set of illustrations examines the techniques I use for these pots and their contents. As an example, I chose a grey stone urn set firmly on a lichen-encrusted plinth, made all the more attractive for many years spent out of doors. The initial line drawing (Fig. 32a) was simple, picking out a few appropriately shaped leaves to act as highlights later on. A basic wash of Yellow Ochre was mixed for the stone undercoat and applied to previously dampened paper. A little Sap Green was applied to this wash (Fig. 32b) and applied to the foliage section, with no real need for blotting at this stage. It was simply given a few minutes to dry. The next stage (Fig. 32c) was to establish the basic tonal values of the pot. For this, a little Prussian Blue and Burnt Umber were added to the undercoat mix and, using a lot of water, washed onto the righthand side of the pot and plinth. As there was an angle on the plinth and a subsequent division of light and shade either side of

*Figure 32a*

*Figure 32b*

*Figure 32c*

*Figure 32d*

this edge, it was important not to blot. This was one occasion when a sharp-edged shadow was useful. The pot, however, was curved and needed to be blotted slightly to avoid *too* harsh an edge to the shadow.

To complete this sketchbook study, the specific shadows, tones and textures had to be introduced to the pot and plinth, and to the ivy. The lip of the pot caught the light and needed to be highlighted to emphasize this. This was done with a small brush and a strong mixture of Burnt Umber and Prussian Blue, applied underneath the lip with a small dry brush (Fig. 32d). Before this had dried I took a medium wet brush and 'pulled' this paint downwards and to the right, following the curve of the pot. While the pot was still wet, the same technique was used on the underside. This involved turning the sheet of watercolour paper upside down (it is easier to 'pull' downwards than upwards). It was important to avoid paint washing onto the foliage, as the ivy leaves caught the light that cast the shadow and needed to be of a brighter tone. The lip and the base of the plinth were also treated the same way. Finally, the foliage was painted using the 'dabbing' technique described earlier.

Garden pots are usually in grey stone or terracotta. For terracotta pots, I use a mixture of Burnt Sienna and a little Burnt Umber to emphasize the shaded areas.

———————  ·  ———————

## FIGURE 33

This Mediterranean-style courtyard (see page 105 for the finished painting) made a wonderful subject with its ivy, dappled shadows and weatherworn stone. The initial pen sketch was a near textbook exercise in two-point perspective, with the converging lines conveniently running along the lines of the stone indents. The architecture was the main feature of the sketch (Fig. 33a). The ivy only needed a few lines, and the cobblestones were also just picked out. It was important, however, to establish the approximate shapes of the plants.

The main feature of this painting was the interplay of light and the way in which it created complex dappled shadows falling onto the warm stone. It was therefore important to establish a solid undercoat to work on, as many layers of water and paint were to follow. A quick wash of basic undercoat colours on dampened paper got the painting under way (Fig. 33b). The foliage, in particular, was treated to a very watery application. This wet paint, when laid onto damp paper, bled instantly, finding its way to the bottom of its 'area'. As it

dried, the residual paint took on a darker tone than the rest, creating some natural shading – the shading would be on the underside of such a thick growth. Before this had time to dry thoroughly, the next layer of paint was applied. Foliage, trees, ivy, etc. often benefit from this 'wet-into-wet' technique as the tones blend and bleed freely without creating harsh lines or edges.

It was time to establish the major shaded areas, including the windows. Using a medium brush and a fair quantity of water, a mixture of Prussian Blue and Burnt Umber was applied to the shaded areas on the stonework and allowed to bleed, with a little help and direction, down the length of the paper (Fig. 33c). A little blotting was required here to preserve some gloriously bright highlights, but in the main the watercolours were left to find their own way. A little Sap Green was added to this mixture and applied to the appropriate shaded undersides of the ivy by way of a few 'dabs'. If a little green flowed downwards onto the damp stone areas, it was disregarded as it only enhanced the 'wholeness' of the painting. One major fault painters often develop when they experiment with watercolour

for the first time is the tendency to fragment and segregate colours. Let them bleed! Colours reflect and absorb in Nature. Try holding a sheet of red card next to a sheet of white card; the white card will reflect the red, taking on a slightly pink appearance.

Having established the major shadows, it was time to work on the dappled effect, which was the main attraction of the scene (Fig. 33d). This involved using a small brush to apply the paint. Exactly the same paint mixture was used to develop the dappled shadows, but the technique varied a little. It involved painting the shaded areas inside the delicate alcoves, under the ledges and underneath the ivy, copying the shapes as accurately as I could. I quickly washed the brush and, using clean water, 'pulled' the paint out slightly, following the line or direction of the shadow, and allowed it to run, blotting quickly with the point of a screwed-up sheet of kitchen roll to create the highlights where appropriate. The same treatment was given to the cobblestones in the foreground – almost drawing on the paper with paint, then adding water to create bleeds and blotting the highlights in quick succession.

This is the technique that I employ, and enjoy, for recording the spring and summer shadows cast by trees, shrubs and other plants which nestle in small courtyards, squares and urban gardens.

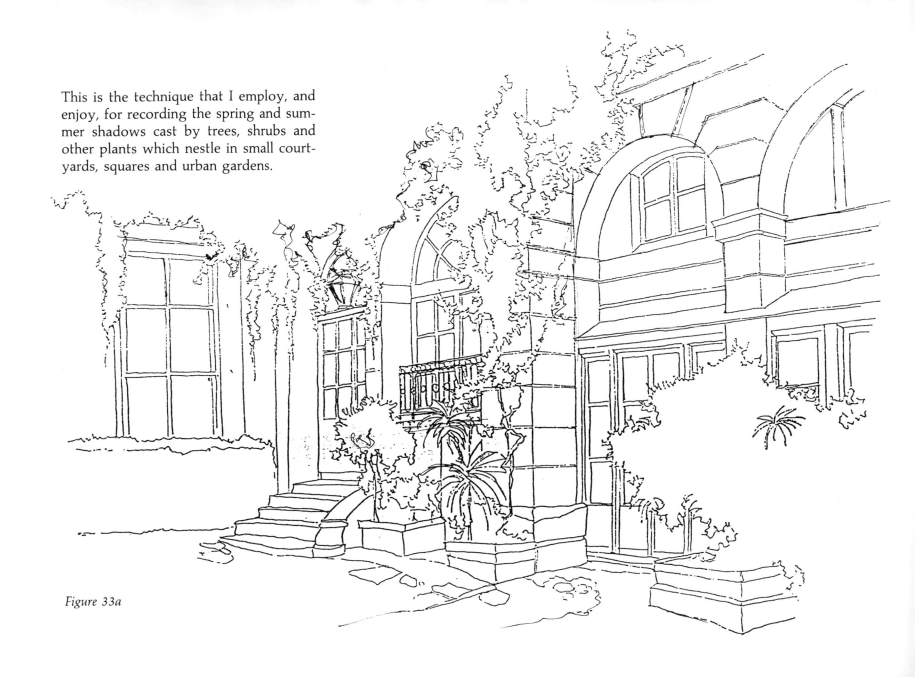

*Figure 33a*

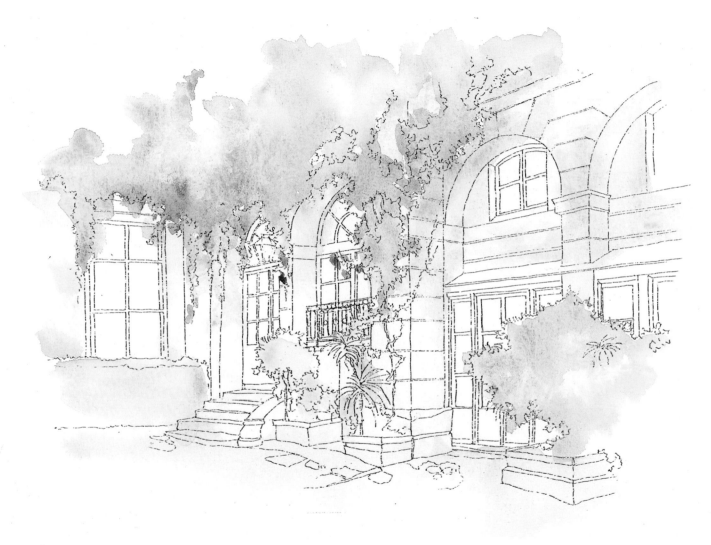

*Figure 33b*

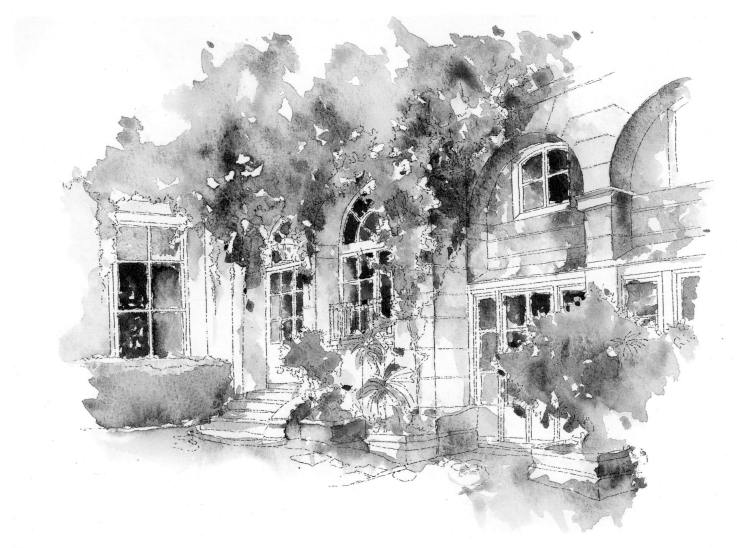

*Figure 33c*

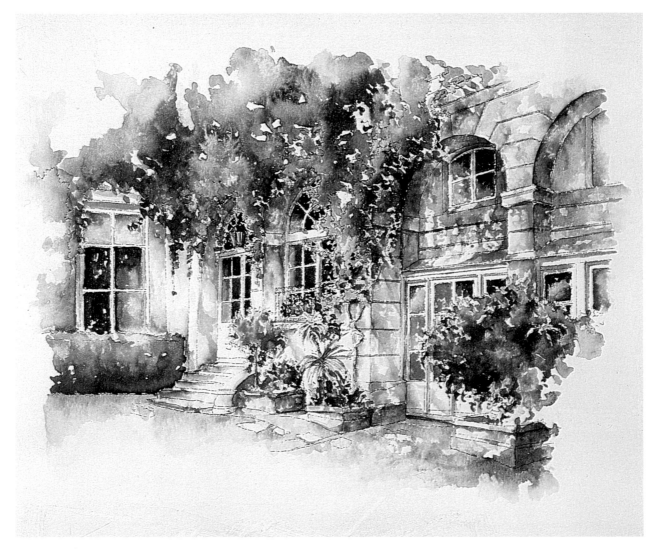

*Figure 33d*

## FIGURE 34

The same technique of applying small areas of paint by 'dabbing' was used in this painting of a flower market, as it is particularly useful for establishing small 'flashes' of colour. In this case, two slightly different techniques were used.

First, to establish a backdrop for the riot of colour produced by the flowers, a 'wet-into-wet' method was employed in the appropriate areas. Where the flowers were stacked high, I dampened the paper and dabbed the appropriate colours — generally red or orange — and allowed the paint to bleed freely within its 'range'. When it had thoroughly dried, I then applied a series of small dabs of bright colour, using a small brush and very little (if any) water. These dabs dried quickly and made an effective representation of the flowers. As the ground was wet, it was even more appropriate to use a whole succession of watercolour washes in the foreground, 'pulling down' the colours from the pots and flowers to act as reflections.

*Figure 34*

## FIGURE 35

My final quiet corner (overleaf) provided a wealth of shading techniques. The flat, architectural shadows, reflecting the shapes of the steel fire escape pierced by a few shafts of light, served as a solid background for the fleeting, dappled shadows falling softly onto the foreground of this quiet public place in central London. A strong summer sky required a fair amount of Prussian Blue to be added to the 'neutral' shadow paint mix. This was painted on with several wet washes and allowed to flow freely, being blotted only when it went astray — the shafts of light on the ground were carefully protected. The passing effects of light need to be captured quickly with a sharp 'dab' and a little bleed. This challenge, in the peace and tranquillity of a suddenly discovered courtyard or public garden, can be one of the painter's greatest pleasures.

I suppose it is true to say that the difference between painting in an urban garden and painting in a rural garden is that you rarely have a sense of wide open spaces around you in a town or city.

There will always be something to remind you, almost reassuringly, that you are still in a built-up area. The constant buzz of traffic or the grimy grey stone towers that hover above your eye-line; even the metropolitan signs in the parks, will serve as a constant reminder that, however peaceful your immediate surroundings may be, busy streets are only a minute or so away. But these little havens provide you with an unusual opportunity to sit and paint at your own leisure, generally undisturbed, allowing several hours of pure artistic self-indulgence — so why not take advantage of them?

———— · ————

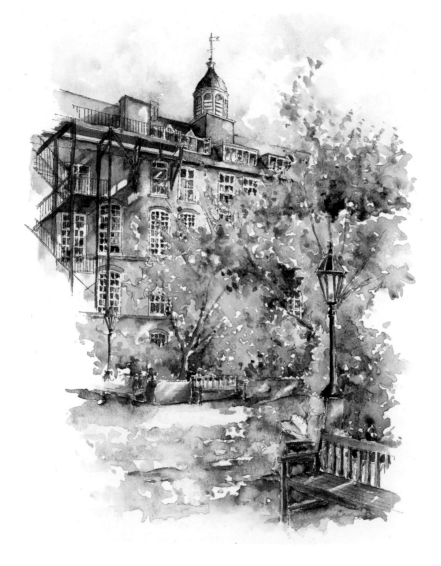

*Figure 35*

# EIGHT

## TERRACES

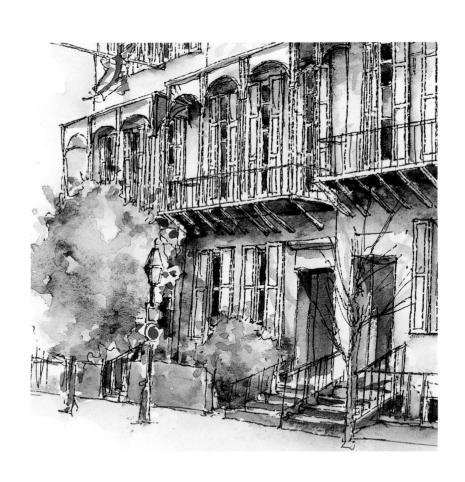

# TERRACES

The terrace, now an international urban convenience, developed relatively late in terms of the history of building. As with most architectural innovations, the idea came from Italy and soon caught on in the highly fashion-conscious London of the late eighteenth century. The concept of the terrace was also instrumental in the development of town planning, affording city dignitaries an opportunity to develop the extremely popular 'square'. The architectural history of the terrace provides some interesting considerations for the artist.

Many older terraces have brick façades, and with good reason. The building of many terraces, once they had been accepted and copied throughout the country, was carried out during the early 1800s, just as the hoped-for long-lasting peace in Europe was shattered by the outbreak of the Napoleonic wars. The nation's hardwoods were soon commandeered for shipbuilding, creating a serious shortage of home-based products, and expensive Scandinavian and American woods had to be imported. Building costs doubled, and the expense was offset by employing unskilled bricklayers to work on the basic construction, and only using skilled workers to complete the façade visible to the public. Consequently, the rears of many terraced buildings contain different-coloured bricks – often the blue-black burnt bricks rather than the brighter red bricks usually found on the front.

Today, however, building materials are regulated, and the standard terrace is found around the world as a convenient form of housing. The stucco front of the middle terrace set against the red brick of its next-door neighbour can provide a visually interesting contrast, as can the array of old and modern chimney-pots, the colourful variety of front doors, and the use of external ornament. All of these are aspects of today's terrace and are therefore of interest to the urban artist.

Unless you plan to undertake a panoramic view of a lengthy terrace (see page 57), you will need to give some serious consideration to the business of perspective, both linear and tonal. Linear perspective involves establishing a network of lines (as demonstrated in Chapter 2) in order to create an optical illusion. The eye is tricked into believing that the buildings being drawn are actually receding into the distance in a three-dimensional way on the two-dimensional surface (Fig. 36).

Tonal perspective can be used to complement linear perspective, and this also involves an act of deception. We only see objects because they reflect light. The further the light has to travel, the less intense it becomes when perceived by the human eye. This is why, in the traditional landscape, the far distance is painted in barely visible tones with no detail, the middle ground is a little stronger in colour, but only the fore-

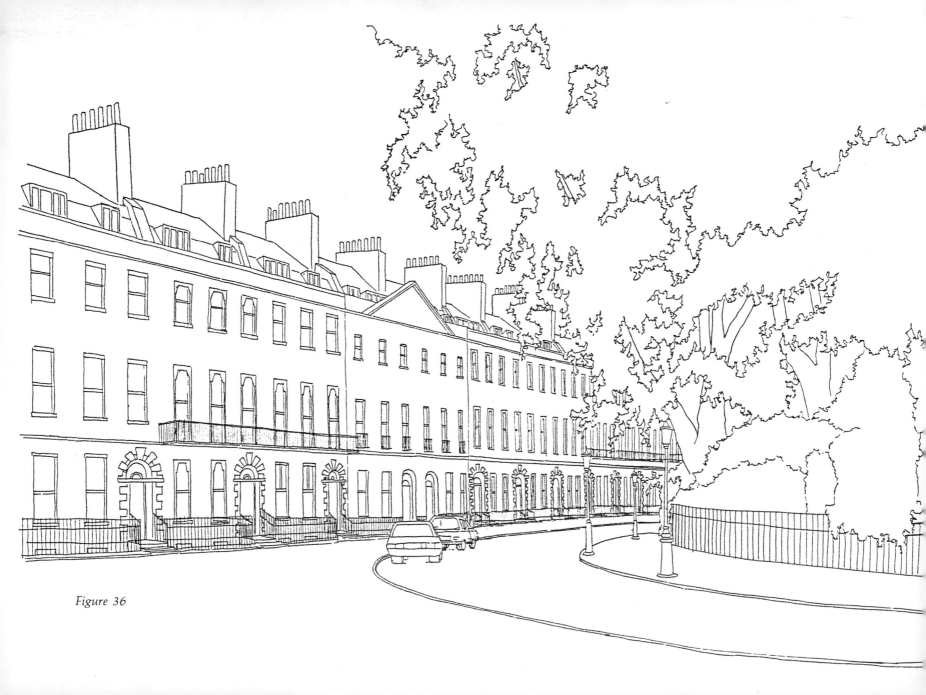

Figure 36

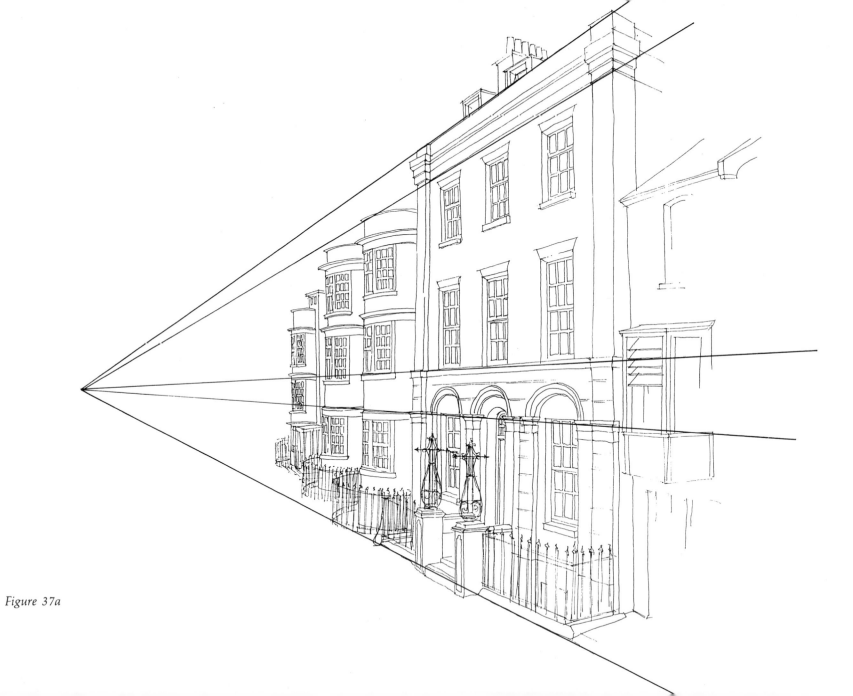

*Figure 37a*

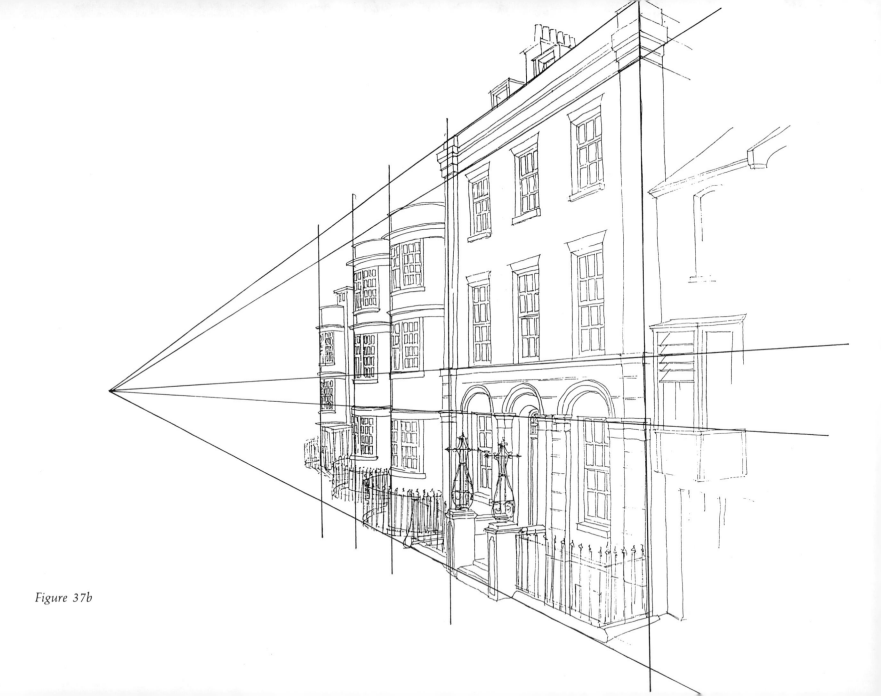

Figure 37b

ground is developed with bright, strong colours. The terrace will also have this structure: a series of lines appearing to recede into the distance, and a tonally lighter far distance.

In Figure 37a the convergence of the upper roofline and the basic ground-line is demonstrated. Both these lines appear to converge at a point on what is often an imaginary horizon called the vanishing point. These lines are only guidelines, and if required (after a few attempts you will be able to judge perspective and will probably have developed the skill of freehand sketching) are perhaps best drawn with a pencil. As was demonstrated in Chapter 2, lines of windows can also be established in this way along with doors, railings, and any of the many other previously mentioned features or additions that make the terrace so appealing to the artist.

Having established the converging horizontal lines, it is important to ensure that all vertical lines are accurate (Fig. 37b). It is very easy, especially for right-handed artists, to develop a lean to the right. This is easily corrected, firstly by a visual check using the edge of your paper as a guide (this will generally be straight),

and secondly by rolling a pen or pencil across your paper, keeping the nib or point in line with the top edge, and ensuring that it runs in a parallel line. Each time you reach a vertical line, compare it with the pen or pencil, which will be vertical, and check that they are aligned.

——————— · ———————

## FIGURE 38

For this attractive Georgian terrace (finished painting on page 119) I used the roofline, the groundline of the main terrace building, and the line of the parapet as the main perspective 'checks'. The first bow-fronted building at the end of the terrace was, in fact, set back a little, hence its visual irregularity. Fortunately, buildings rarely fit exactly into a geometrically regular grid, and the perspective grids are, as mentioned before, only guidelines. Having established the initial line drawing and the basic colour scheme (Fig. 38a), the studio-based painting was started.

My first compositional consideration was whether to include any sky in the painting. Although a part of the sky was visible, I decided to treat this as more of an architectural study, focusing the viewer's eye on the wealth of detail. With this in mind, the paper was treated to a clean-water wash and given a few moments for the water to soak in. If you work on paper that has only just been washed, the surface water will control the flow direction and ultimate positioning of your paint. If you leave it for a few

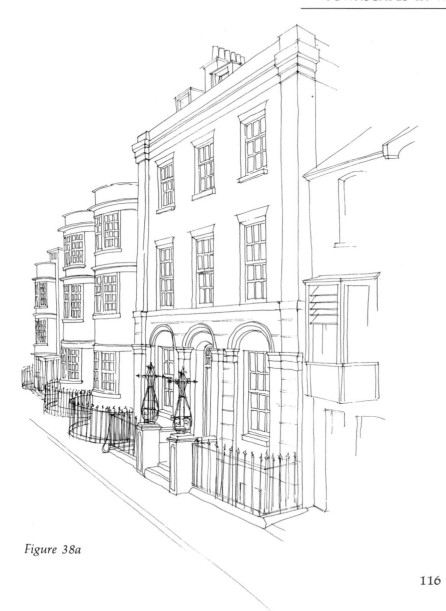

*Figure 38a*

minutes, allowing the fibres time to absorb the moisture, you will be working on damp paper. This will absorb the watercolour paint but still give you the freedom to blot and wash, allowing movement of paint if required.

Although no sky was included in the composition, its effect could not be ignored and was given serious consideration when it came to mixing colours. The tone of the sky will set the 'mood' of the day in terms of colour, so a little Prussian Blue was added to some Burnt Umber to establish a basic brick colour for the middle and background bow-fronted buildings, whilst adding a little Yellow Ochre to establish the warm stone and stucco tones of the foreground building (Fig. 38b). These were then washed on to damp paper and selectively blotted with a piece of textured kitchen roll. In the blotting process I looked for old, weather-worn patches or areas that reflected or caught the light of the day. The level of dirt and grime in the urban environment is high, so the running and blurring of pure colours will not always be a bad thing. A little 'greyness' is often required.

As no roofs, slates or tiles were

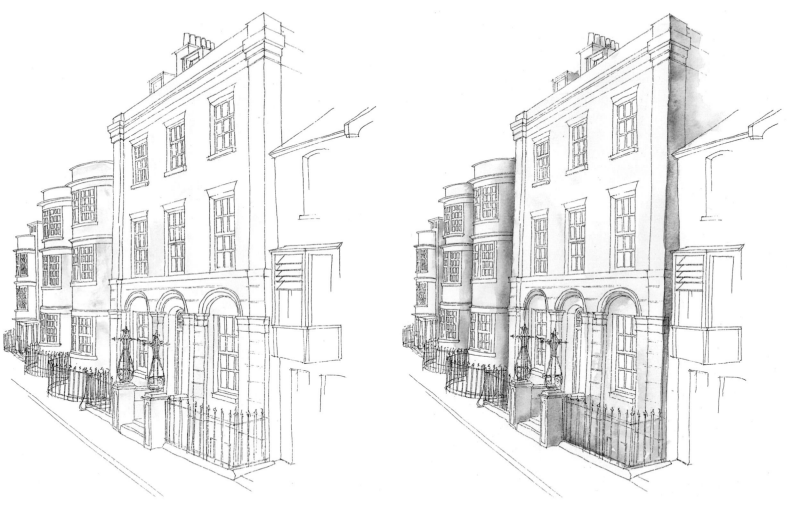

*Figure 38b*

*Figure 38c*

visible (the picture having been drawn from ground level), I could go straight on to the next stage of blocking in the main areas of shadow (Fig. 38c). On terraces such as this with some complicated ornamental architecture, it is important to avoid the temptation of rushing into detail too quickly. The window recesses, the arches of the door frame and the decorative parapets all cast shadows on to their immediate surroundings, but needed to be left until the direction of the main light source had been established and the solid main areas of shadow painted in. This was done, again giving full consideration to the 'mood' of the day, by mixing colour that was not too dominated by a cold sky-blue in an attempt to maintain a little warmth. For this reason the next application of paint was a mixture of Prussian Blue, Burnt Sienna and a little Yellow Ochre, but with the warm brown of the Sienna being the dominant tone. This was painted onto paper that was still damp from the initial 'undercoat' application and allowed to bleed a little. As harsh shadows and edges were not required at this point, bleeding was quite acceptable.

At this stage, tonal perspective was developed. The buildings at the far end of the terrace, as we have seen, need to be of a lighter tone to give the impression of distance. By leaving the very farthest building with just the basic 'undercoat' wash, treating the middle buildings to a slightly darker-shaded wash, and allowing the foreground building the intense shading, a 'depth of field' should be established. It is standard practice, and with good reason, to start with the background and work towards the foreground in creating tonal perspective.

Another consideration at this stage was the brickwork. Clearly, where this exists, it is neither possible nor desirable to paint in every brick course. One of the beauties of watercolour work is its immediacy and spontaneity, and this could all be lost in the desire to produce architecturally accurate plan drawings. It is therefore important to consider 'suggestions' of bricks and façade details. This can be done by combining paint and penwork. The few patches of wall or brickwork to be highlighted can be blotted and, sometimes, be treated to an additional wash of the appropriate colour or tone and allowed to dry. When – and only when – the paper has dried, the colour chosen to suggest brickwork can be picked out with a broken penline. If you try to draw onto damp paper, the pen nib will often scratch the paper's surface, raising the fibre and creating a white outline, rather than the pen line required.

The painting had now established tonal perspective with the beginnings of suggested brickwork. It was allowed to dry before moving on to the next stage of including main details by way of the shadows in the window and door recesses, the window panes, and under the parapets (Fig. 38d).

This (penultimate) stage required the use of a finer brush than had previously been used. The method employed for completing this stage was to apply a line of fairly thick paint on the underside of the recess. Before this had had time to dry I used a damp brush to 'pull' the paint down along the line of the shadow. The advantage of this two-stage process was that, when the first application of thick paint applied to dry paper began to dry, the pigment stained the paper, creating the dark, immediate shadow. The residue pigment was reconstituted with the water wash as it was pulled out and a diluted and consequently

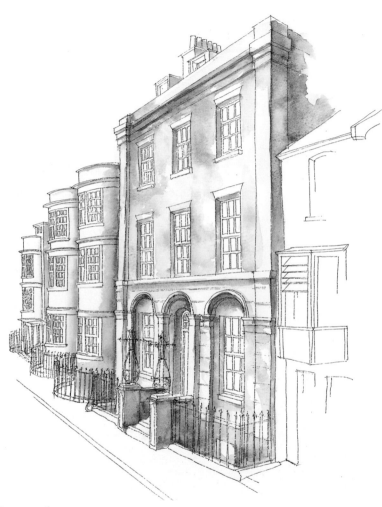

*Figure 38d*

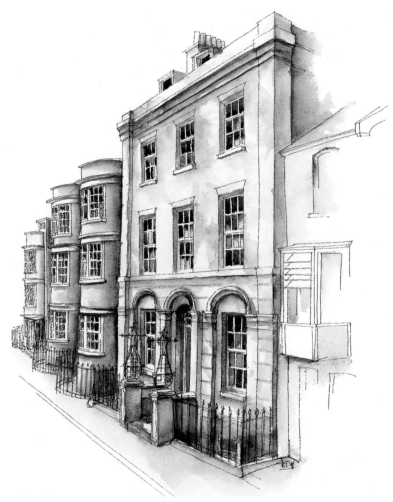

*Figure 38e*

lighter tone served as the graduated shading. My colour mixture for this section was, again, a mixture of Burnt Umber and Prussian Blue.

The final stage (Fig. 38e) required general 'tidying up' and the application of finishing touches that, in this case, involved picking out sections in pen (after a succession of watercolour washes the initial pen lines will lose their intensity and may need to be reinforced). This particular painting needed attention to some of the foreground details, especially the railing and ornamental wrought-iron work to the front of the main building. It was also appropriate here to highlight in pen the outer lines of the window and door frames, accentuating and emphasizing the shadows that give the picture its depth, and complementing the tonal perspective.

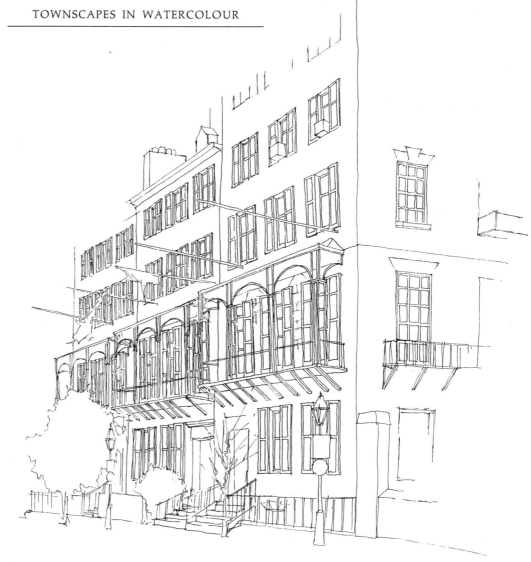

*Figure 39a*

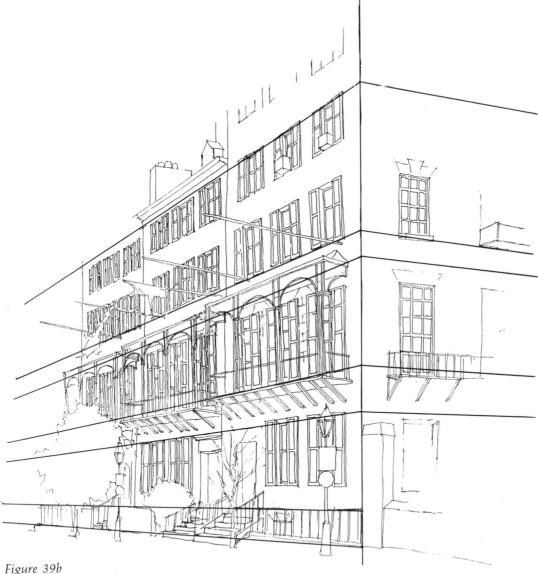

## FIGURE 39

This painting was a very challenging exercise in recording a great deal of detail within a linear-perspective framework. The wrought-iron work and the balconies, the balcony supports, the many windows and the window shutters on this American terrace all had to be sketched accurately in order for the painting to be a success (Fig. 39a). The flagpoles created an unusual diagonal feature, but the particularly interesting aspect of the composition was the element of two-point perspective involved. This has been covered in more depth in Chapter 2, but, briefly, this involves establishing two (in this case, imaginary) vanishing points. These occur on opposite sides of the central corner line. When you have two sides of a building in view, they both appear to converge to their respective points (Fig. 39b).

This was one of those pictures where the application of paint was not exactly secondary, but was certainly not as important as the pen line drawing. The distance covered was not really enough to introduce tonal perspective fully, so the linear perspective had to 'carry' the

*Figure 39b*

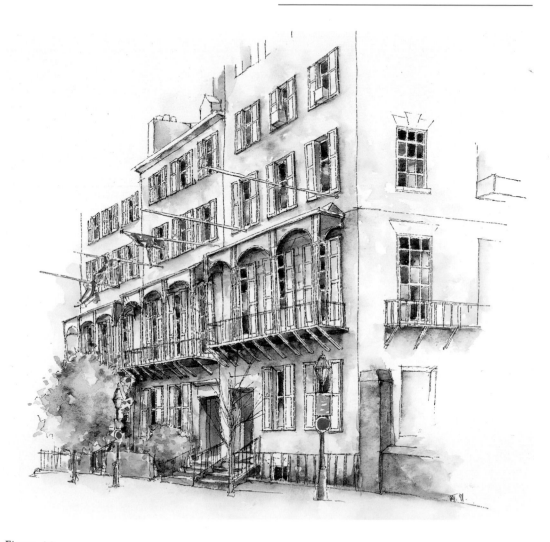

*Figure 39c*

composition. The main concern from the painting aspect, however, was to ensure that the shadows were correctly placed and that the reflections from the window panes were not so regular as to become dull (Fig. 39c). A very fine brush was required to run shadows along the side of the many window shutters and recessed edges, 'pulling' the paint downwards with a wet brush as explained on page 75.

The fundamental considerations when painting terraces are to observe the practices of linear perspective, making sure that your horizontal lines converge evenly, and that your vertical lines remain accurate. When it comes to painting, always ensure that the far end of the terrace appears tonally lighter than the foreground; this tonal perspective will enhance the linear perspective and create a convincing impression of length and depth.

———— · ————

# CONCLUSION

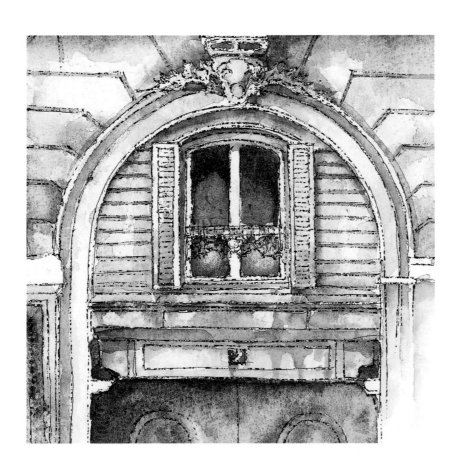

# CONCLUSION

So, what now? Having mastered assorted new skills, you are in the enviable position of becoming a prolific watercolour painter. But what will happen to the paintings you produce? As I have emphasized throughout this book, I firmly believe that sketchbook-keeping can be an end in itself and a pursuit that artists have followed over many centuries. Keeping personal records and notes of painting expeditions made during the summer, if only to browse through during the long winter evenings, can be a most worthwhile exercise and will often bring back more memories than a photo-album. These can be stored easily, flat in a drawer. What then about the finished paintings? Could you live with them on your walls? Are they good enough for your local Art Society exhibition, or could they make precious personal gifts for friends? Whatever you decide, there will come the time when you need to have one of your watercolour paintings

framed. I have always maintained that you will never make a bad picture look good, but you can certainly make a fairly competent picture look very attractive and a good picture spectacular with a well-made frame and mount. My initial advice here is plain and simple. Unless you are a highly skilled craftsperson, good at cutting card and wood, take your picture to a professional framer.

Oil and acrylic paintings tend not to need mounts, but I firmly believe that watercolour paintings need a card mount or surround and, personally, I would generally choose a light colour. A wide variety of card/mounting boards are available, and any reputable picture framer will stock a bewildering assortment. Neutral greys or natural stone colours are a good starting point. However brightly coloured or subtly tinted your pictures are, they will rarely benefit from a strong-coloured mount, which would create a serious distraction from

the actual picture. If this all seems rather plain, then a 'line wash' can break the neutrality of a mount without creating a glaring visual distraction. Again, this is best left to a professional framer until you have had several attempts at it yourself, especially with the cost of mounting card being so high. 'Line washing' involves drawing a couple of tramline borders around the window of the mount, using either coloured pencil or ink. The space in between is then filled with a light watercolour wash, reflecting one of the softer colours from the painting. The difficulty comes when, assuming you loaded your brush with enough paint to get all the way round, you arrive back at the original starting point where it is very difficult to avoid an obvious join.

As with mounts, most framers stock a vast array of framing moulds – gilded, moulded, plastic, wood, carved, inlaid, etc. The most important point to remember is that it is the painting that is on

show and the frame is to enhance it, not the other way around. Wooden frames are generally successful, as are the less ostentatious gold gilt frames; but not excessively decorated moulds, which are best left for ancestral portraits.

There are, of course, other methods of presenting paintings than framing them in the traditional manner. 'Clip mounting' is a popular method of displaying watercolours but it should not be seen as a permanent solution. With 'clip mounts', the painting is simply held in place against a backing board and a sheet of glass is placed over the top and clipped at the top, bottom and sides. It may be mounted (white is a very attractive colour for 'clip mounts') or not, depending on personal preference. This method of display can enhance a simple sketch, or give a light and airy feel to a watercolour, and complete units are generally available at department stores. The disadvantage is that dirt and dust can, and will, work through to the painting, between the glass and the backboard.

If you wish simply to be able to display your finished paintings (mounted or unmounted, depending on preference), a portfolio may be useful. A wide range are available from art shops, the best ones being those with transparent plastic sleeves which clip into the carrying case. Paintings can easily be slid in and out of these so your display can be changed or updated constantly. Portfolios are useful if you decide to take a more commercial attitude to your work; they are good for viewing and look professional.

But perhaps you feel you need a little more than a watercolour pad, paint set and portfolio? All local education authorities run general art evening classes, but you may have to look a little further for specialist courses in watercolour. Many art schools and colleges run summer or weekend courses. These are usually specific courses, aimed at the painter with a little experience. Advertisements for these can be found in the pages of art magazines, most of which are available from newsagents or art shops.

If you feel that you need more support than instruction, then most areas have an art club or society. Many are made up of enthusiastic amateurs who hold a church hall exhibition each year. Others attract semi-professionals with access to more prestigious galleries. Whatever your level, I have yet to hear of an art club that has not welcomed new members with open arms.

My final comment would be that a finished painting, however attractive, need not be your ultimate goal. Sketchbook pages, 'thumbnail' sketches and studies are all of equal value and will, ultimately, enhance your skill and subsequent enjoyment — and that really is the key to it all!

Watercolour painting is not expensive and, thanks to the manoeuvrability of the small amount of equipment required, is available to all. It can bring hours of pleasure, and if my advice throughout this book can add to your personal enjoyment, so much the better. Good painting.

# INDEX